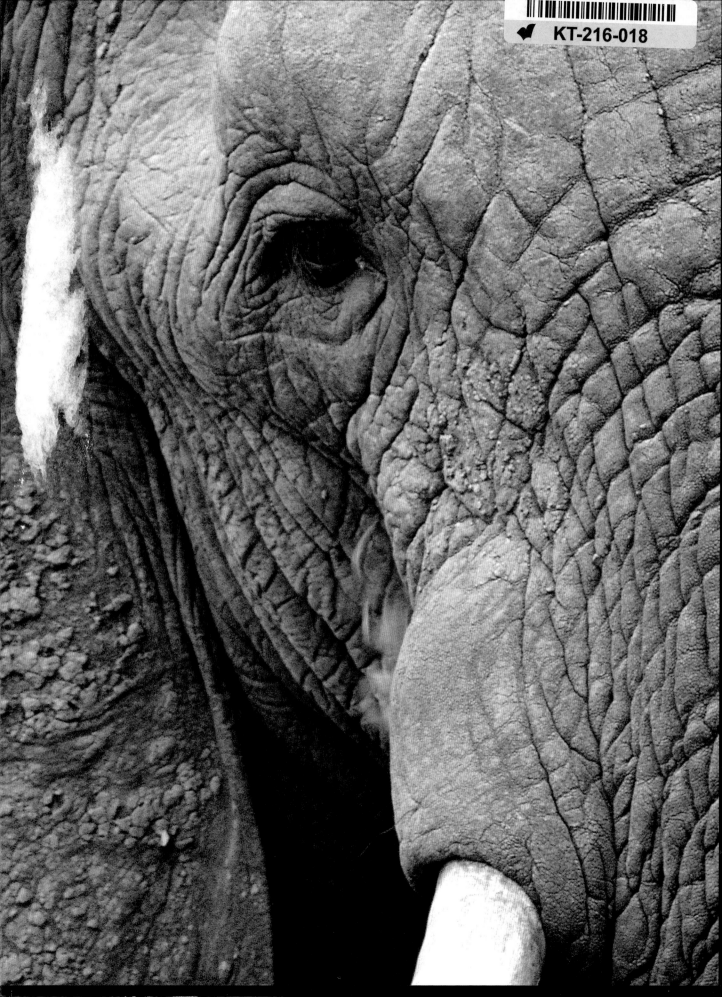

BOTSWANA

NAMIBIA

Contents

Map symbols

 Lodges or hotels

Camp sites

Roads or highways

Dirt roads (4x4)

National parks and reserves

Key to photo symbols

 Wide angle lens: from 20 to 35mm

Medium angle or standard focal length lens: from 70 to 300mm

Long focus or telephoto lens: from 400 to 600mm

Xakanaxa

Moremi
Reserve

OKAVANGO
DELTA

Maun

to Ghanzi

BOTSWANA

Central Kalahai
Game Reserve

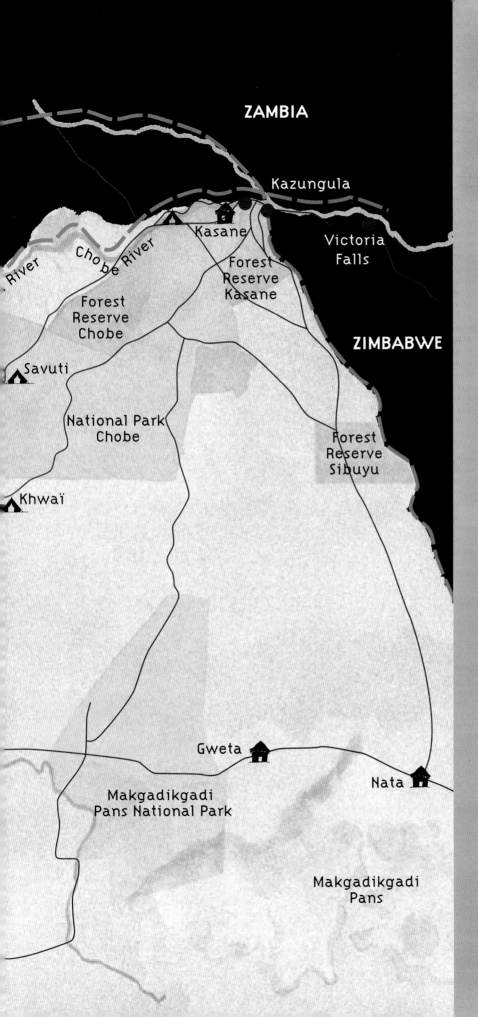

ZAMBIA

Kazungula

Kasane

Victoria
Falls

Forest
Reserve
Kasane

River

Chobe River

ZIMBABWE

Forest
Reserve
Chobe

Savuti

National Park
Chobe

Forest
Reserve
Sibuyu

Khwaï

Gweta

Nata

Makgadikgadi
Pans National Park

Makgadikgadi
Pans

Located within the confines of southern Africa, Botswana is a choice destination for wildlife photography. The country provides a rewarding alternative to the East African safaris and deliberately encourages a more elitist tourism market. Through higher costs and important logistical constraints, the local authorities clearly want to limit the flow of foreign visitors and to manage their environmental heritage in the best way possible. Travelling in Botswana is therefore something of a privilege. It provides the opportunity to explore an extraordinary country; a country in which wild and hypnotic beauty spontaneously reveal great contrasts shaped by magical lighting, imprinting dreamlike images on our memories.

3

BOTSWANA

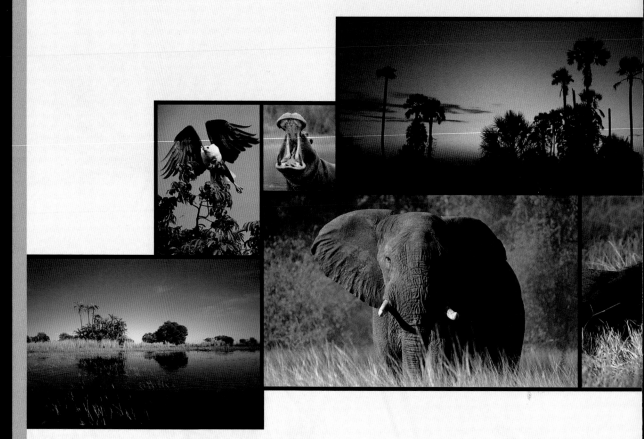

I ndependent since 1966, democratic and prosperous Botswana has a population of some 1.7 million inhabitants who reside mainly within the 15 per cent of sovereign territory that has not been encroached by the Kalahari Desert. Covering an area of about 570,000 square kilometres – making it a little bigger than France – Botswana borders South Africa to the south, Namibia to the west and north, and Zimbabwe to the northeast. The country does not, therefore, have a coastline, which explains its semi-arid continental climate: excessively hot and humid in summer from November to March with sporadic rainfall; more cool and dry in winter from May to August, with some nights turning very cold. The other seasons – April-through toOctober months are dry. Very rare

to rain in winter. Mostly comprising a vast rocky plateau about 1,100 metres above sea level covered by a sand basin, Botswana owes its fame to two large ecosystems. The Kalahari Desert covers about 85 per cent of the country's total territory and includes much of the Kgalagadi Transfrontier Park, the leading trans-border park co-managed with South Africa since 1998. In complete contrast is the Okavango, a giant inland delta whose natural wealth unquestionably makes it one of the wildlife jewels of our planet.

Noted for the extreme flatness of its relief, Botswana nonetheless has a few eroded rocky uplands which culminate in Mount Otse in the extreme south of the country at a height of 1,491 metres; and in the northwest corner

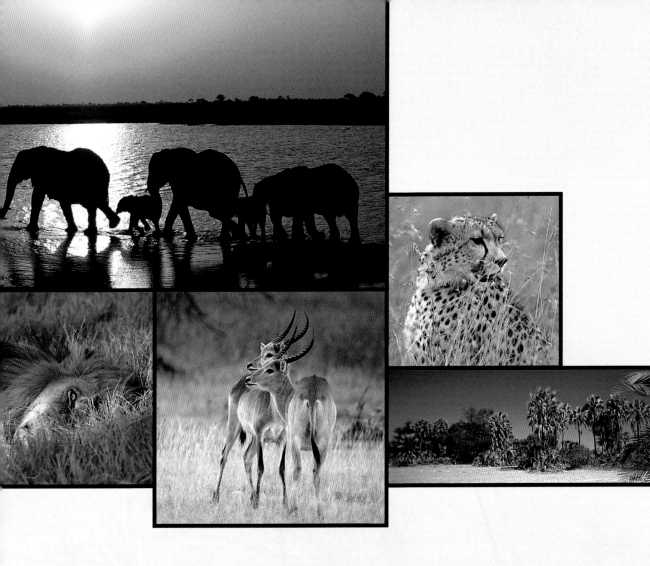

the Tsodilo Hills which have unusual landscapes reaching a height of 1,375 metres. The variety of environments within Botswana, give rise to a multitude of habitats. These, in turn, sustain an astonishing profusion of animal species that freely develop and flourish at the heart of this mosaic. Botswana is, in effect, one of the continent's last wilderness sanctuaries. It accommodates large numbers of Africa's key fauna mostly concentrated within parks and reserves. Some 164 species of mammals, among which the rhino has recently been reintroduced, about 150 species of reptiles and 550 species of birds colonise Botswana's near virgin paradise. Additional rhinos have been introduced to Moremi Game Reserve. Despite the ubiquitous desert, Botswana is home to more than 3,500 species of plants. The southwest of the

country is dominated by a bushy savannah; while in the east small islands of prairie vegetation form around dried-out water pans. A wooded savannah occupies much of the rest of the territory although, to the north, the rich soil of Okavango is the domain of mopane forests. The immense oasis, formed by the delta, offers an atypical exuberant vegetation. In this book, we have sought to introduce the reader to the most beautiful of the wildlife locations. Our recommended itinerary starts with the Makgadikgadi Pans before plunging into the labyrinthine Okavango Delta to visit the Moremi Wildlife Reserve. Then it proceeds north through the Savuti Marsh to reach the river precincts of Chobe National Park. The journey culminates in Zambia or Zimbabwe with the unforgettable spectacle of the Victoria Falls.

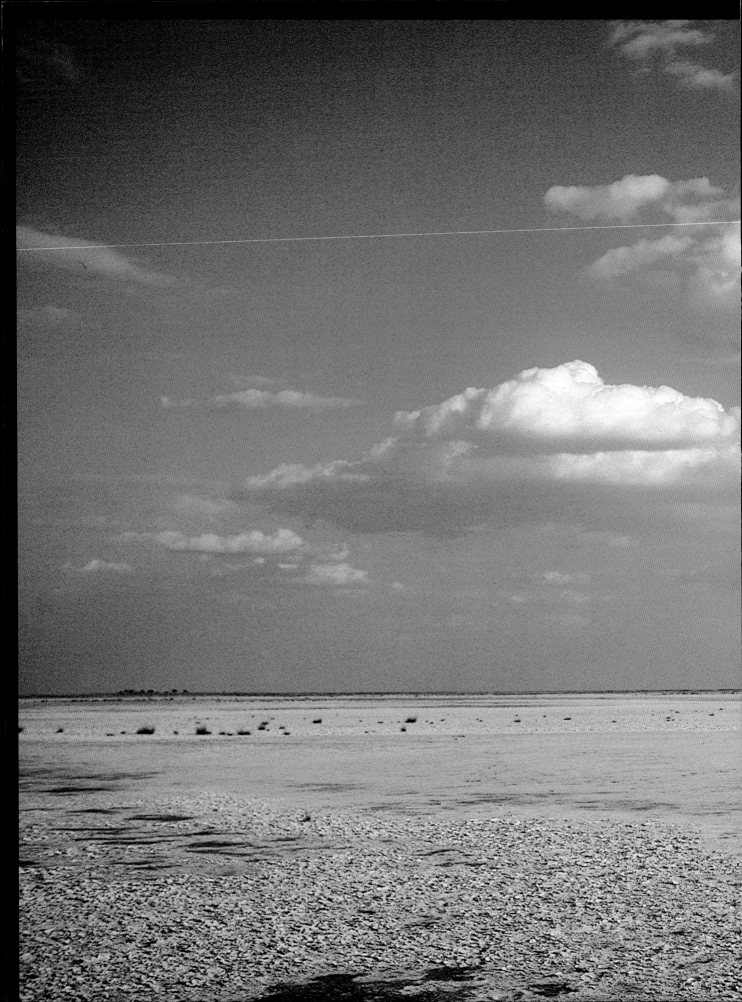

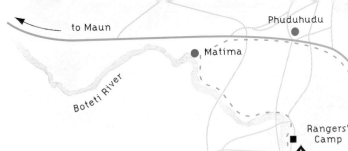

to Maun

Phuduhudu

Matima

Boteti River

Rangers'
Camp

MAKGADIKGADI PANS
NATIONAL PARK

Makgadikgadi Pans

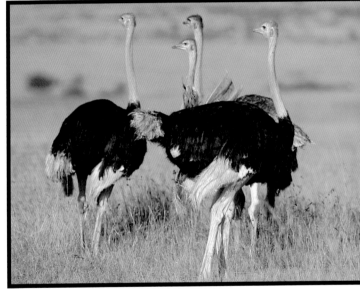

Ostriches like to frequent the open savannah, doubtless to anticipate possible danger more readily. Somewhat shy, they always keep their distance so that they can escape easily, which is why a long focal length lens is necessary. Their alertness prior to making their getaway gives the shot particular interest.

Pans, which are shallow saline basins varying from a few meters to several kilometres in diameter, are a common feature of Botswana's landscape. They retain summer rains until the dry winter months and guarantee a water source for man and beast. About thirty thousand years ago, the Makgadikgadi Pans constituted the largest lake in Africa. It was probably fed by the Zambezi, Okavango and Chobe rivers and is estimated to have extended over some 80,000 square kilometres. But the region's seismic activity and climatic upheavals probably explain the drying out process. As a result,

In the north of the Kalahari, the large saline flats, formed from the drying out of the old Makgadikgadi Lake, afford the opportunity to photograph unusual scenery. The use of a wide angle lens makes it possible to capture the sense of space more accurately.

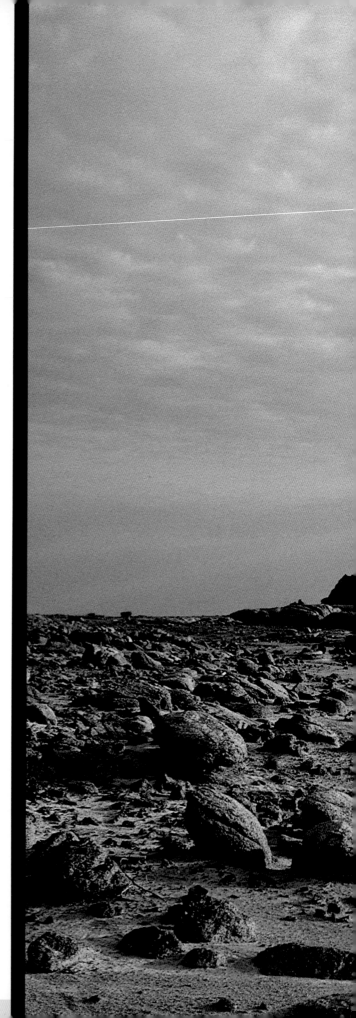

there are now only two principal pans: the Sua and Ntwetwe. Together, they cover about 12,000 square kilometres. A small part of their territory falls within Makgadikgadi National Park which extends over 4,900 square kilometres. Created in 1992, it replaced an earlier animal sanctuary established in 1970. The pans rarely receive more than a few centimetres of rainfall, so they remain dry for most of the year. But appearances are misleading, for hidden beneath their saline crust is a runny sludge. The pans are places of mirages. When the sun beats down on their white crust, the misty heat distorts animal silhouettes to create fantasy creatures whose presence in such hostile settings both surprises and fascinates the traveller. The best time to explore Makgadikgadi is just prior to the rainy season. In September herds of wildebeest, zebra and antelope arrive to await the first rainfall. Then around December, when the sky fills with heavy rain clouds, all manner of aquatic birds congregate on the water. They come in their millions to breed in

Occasionally, small groups of granite boulders breach the rectilinear horizon of the pans. As a result, the landscape appears almost lunar. When the sun lengthens, the shadows redefine the bulk of the rocks. In the morning or evening, it also enriches the graphic shapes of the shot. The result is an eerie but original picture.

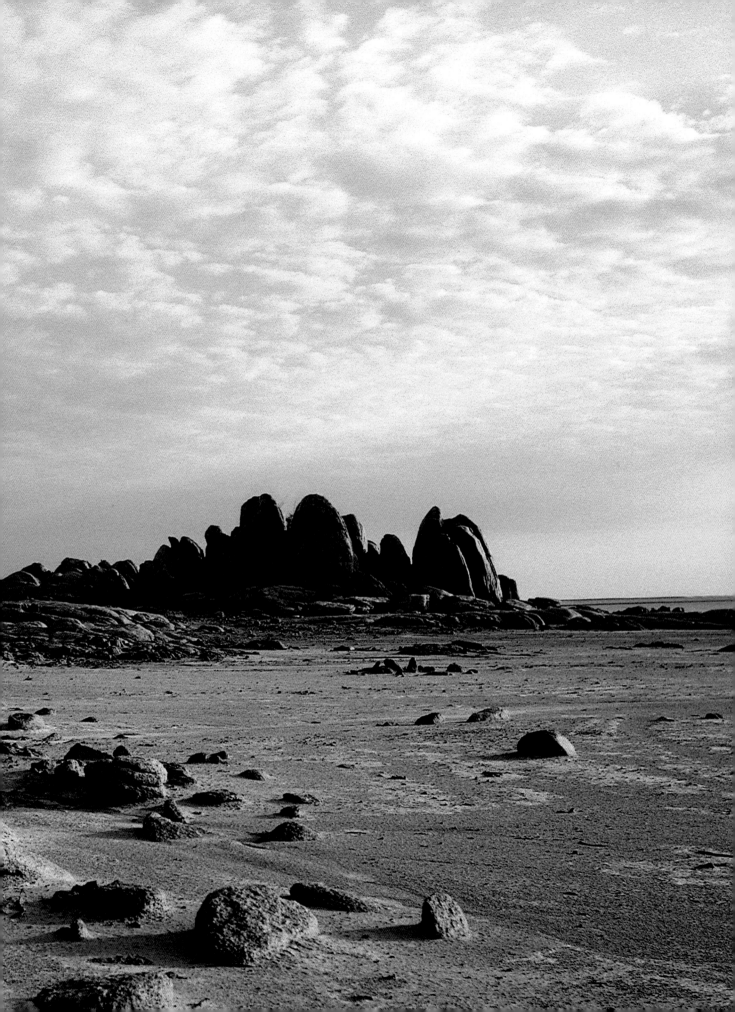

this ephemeral paradise. In addition to significant colonies of flamingos from East Africa, the pans welcome more than 165 species of birds including numerous pelicans, yellow-billed storks, spoonbills, bustards, teals, avocets and diverse varieties of lapwing. The saline clay of the pans is completely sterile and the total absence of flora contributes to the sense of desolation that envelops such places. Footprints in the sand testify to the occasional

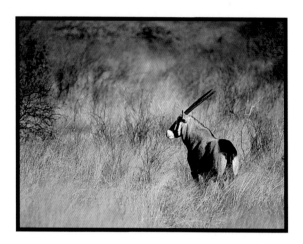

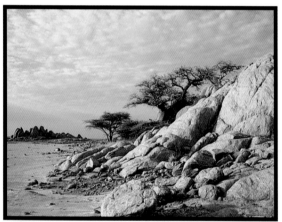

presence of animals which prefer the neighbouring grassy plains that are sometimes dotted with mopane, palm and baobab trees. The relative abundance of this vegetation feeds numerous species – both resident and transient. These include ostrich, kudu, giraffe, steenbok, gemsbok, springbok and even the occasional elephant near the Boteti River. In turn, these herds of herbivores attract their predators. Amongst the most commonly seen are lions, cheetahs, jackals and, more rarely, brown hyenas. As in most desert settings, reptiles, tortoises, snakes and lizards also seek out a choice habitat. Here, wildlife resolutely finds resources and refuges even in the most hostile of settings.

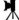

Concealed by tall grasses, numerous animals – including the gemsbok – take shelter in the savannah surrounding the arid pans. The colouration of the gembok's coat blends in with the surroundings. Even when spotted, it is difficult to approach, because it always maintains a safe distance; the only hope of getting a photograph before it takes off, is by using a telephoto lens.

A seed carried by the wind? Or dropped by a bird? How else can one explain the incongruous presence of this baoab, rooted within the middle of the desert? Ensconced in an island of rocks, it makes a surprising shot.

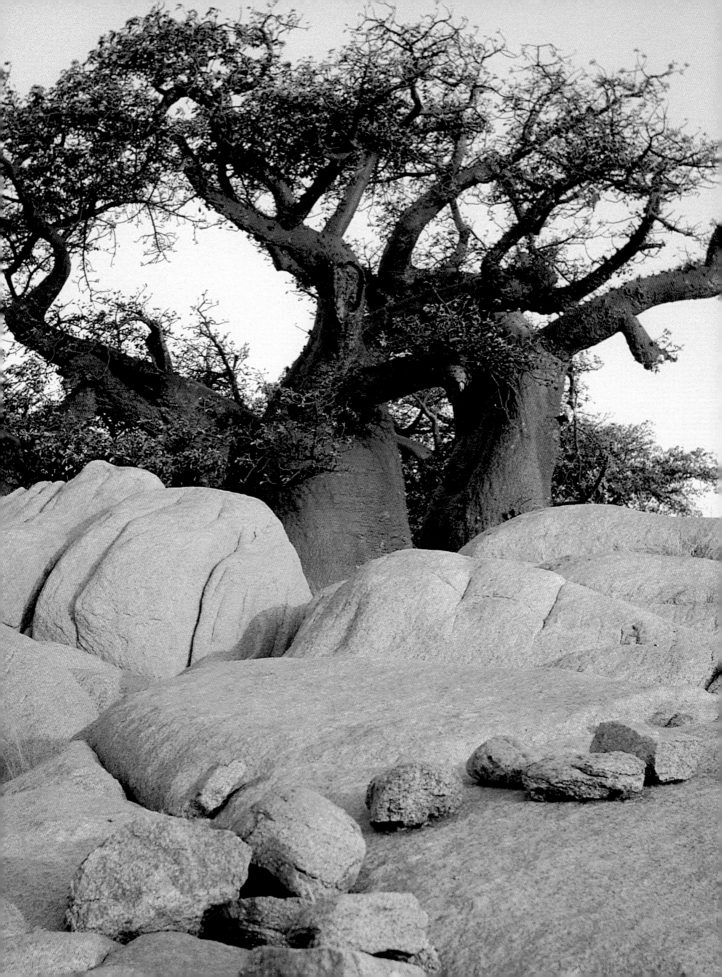

In the very early morning, when the sun has barely lit the horizon, these silhouettes of palm trees produce a wonderful foreground. As well as emphasising the contrast with the sky's subtle gradation of light, it also highlights the semi-circular shapes of the vegetation. Due to the distance between the sun and the trees, to achieve this effect, you need to find a viewpoint well away from the central subject and use a medium to long focal length lens.

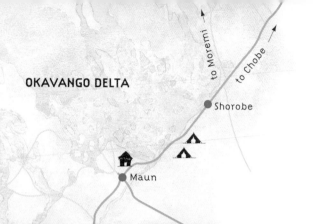

OKAVANGO DELTA

Shorobe

to Moremi

to Chobe

Maun

Made up of channels and lagoons, the delta, which some cross by mokoro (dugout canoes), others by motorboat, offers visitors beautiful floral displays and tranquil settings. It is best to use a polarising filter to accentuate the contrast between water and sky with this type of subject.

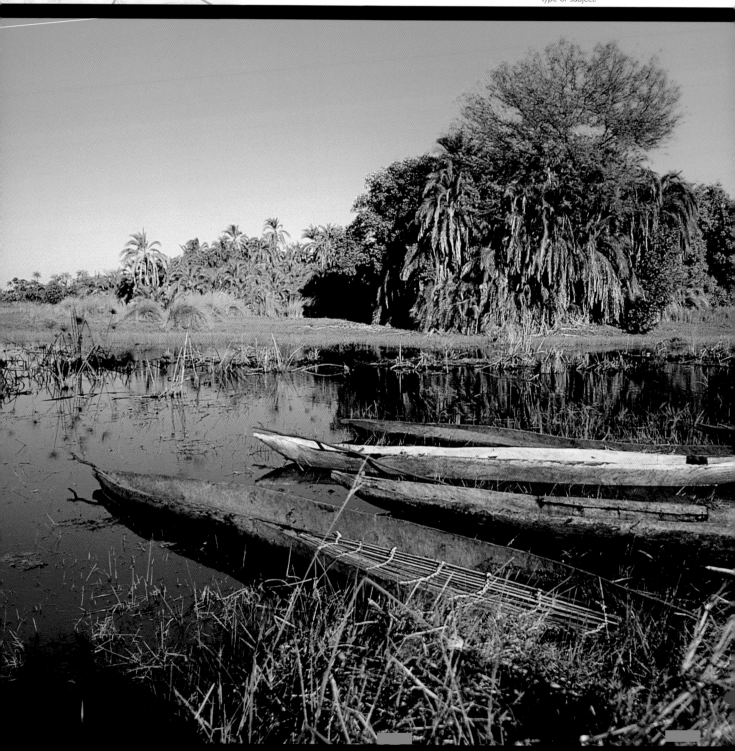

Okavango Delta

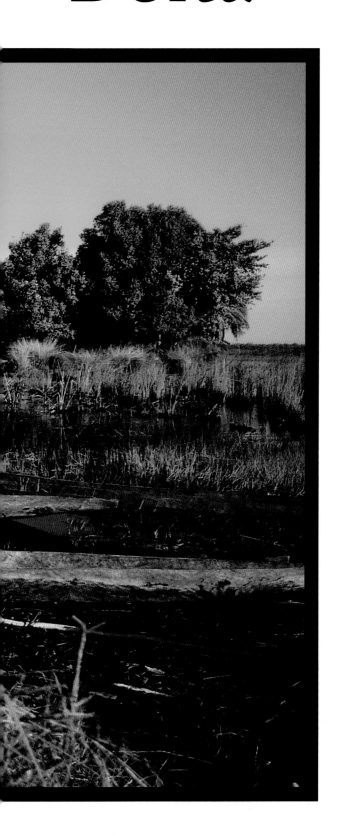

The third largest river in southern Africa, the Okavango, rises in the high plateaux of neighbouring Angola where annual rainfall sometimes reaches 2,000mm. Then, instead of heading for the Atlantic Ocean, the river turns inland and flows on for some 1,300 kilometres before entering Botswana. Initially, it takes the form of a long channel known locally as the Panhandle. This is the northern part of the river at the end of which the Okavango is carried between two parallel faults in a south-easterly direction. It then winds for about 100 kilometres before fanning out into a wide area of channels and lagoons to create the world's largest inland delta. It is both the direction and abundance of the precipitation occurring in the uplands of Angola which determine the river's level. By March/April the rainy season which occured at the river's source, forces about 150,000 billion cubic metres of water surging down through the Panhandle around Delta, uprooting vegetation in its path and carrying with it vast tonnes of sand and soil. But this soon diminishes and it is only after several months, because of the flatness of the ground, that the water finally spills into the delta. This inflow extends over 15,000 square kilometres and accounts for about 90 per cent of Botswana's water reserves. As a result, the smallest dry spell can have catastrophic consequences (notably for the town of Maun which is totally dependent on this seasonal supply).

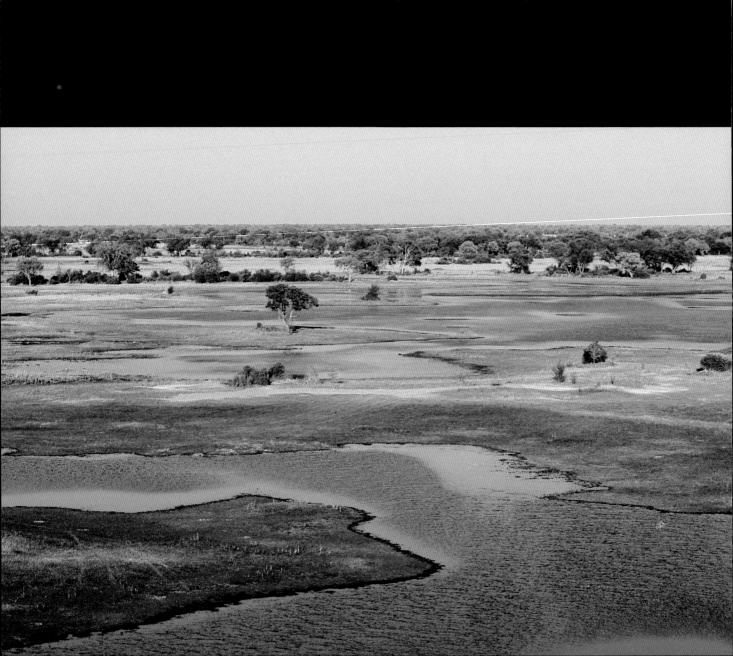

Shaped by fractures in the earth's crust, most of southern Africa's rivers somehow never seem to reach the ocean. The same applies to the Okavango whose clear waters evaporate into the burning sands of the Kalahari Desert, while tributaries flow into the Boteti and Thamalakane rivers. Due to a system of complex and almost imperceptible geological faults, other streams reach into the distant Lynianti Marshes. Constant physical changes are one of the delta's distinctive features. In fact, the vast quantity of alluvial deposits churned up by the river – sometimes blocking channels in the process – are an ideal resource for termites which use copious amounts of silt to build their fortresses. These insects build on such a scale that their edifices may sometimes form the basis of a new islet. There are estimated to be some 50,000 of these mini-islands throughout the delta and every day, through the action of continuous animal movements, new islets appear and disappear. For example, the comings and goings of hippopotamus and elephant cutting new passages, coupled with the region's very slight but continual tectonic activity, constantly alter the route of secondary channels. In addition, bush fires sparked by violent thunderstorms can also re-shape the delta's geography. This remarkable oasis at the desert's periphery creates an ideal habitat for multitudes of

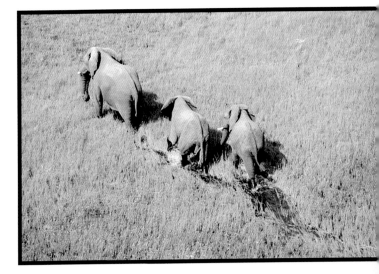

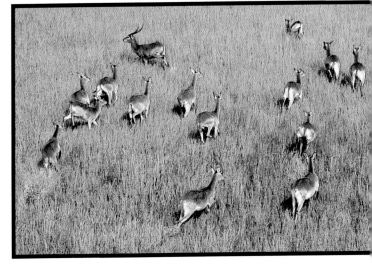

The little town of Maun, which in a way is the delta's entry port, is the starting point for many tour operators. It is from here that flights over Okavango are organised. A helicopter has the advantage of flying at lower altitudes which allows for better pictures. In this case there is no point in burdening yourself with too many lenses, because a medium focal length zoom will cope with most possibilities perfectly well.

wildlife, most of which converge here during the dry season when the skies are blue for weeks on end. Fed by summer rains from the upland plateaux of Angola, it is essentially during the southern winter that the delta's water level is at its highest because the water's progress is extremely slow.

This damp ecosystem hosts almost 40 species of large mammals. Amongst the most common antelopes are the elegant impala and the majestic greater kudu which both lend themselves to photography in wonderful settings. The native lechwe proliferates freely within the labyrinth of marshes and canals. Its population is put at almost 30,000 and it is quite common to see large herds. A rarer sight is the timid sitatunga, a semi-aquatic antelope, which is best approached in a dug-out or mokoro as it often lies low in the reeds. As for meeting a pack of wild dogs, only luck arranges a close encounter with this remarkable animal, with its wolverine habits. But what a thrill it is to see its slender silhouette trotting along the banks of a river with its fellow canines. Conversely, seeing zebras – eminently photogenic with their striped coats – is never a problem. Elephants are equally numerous and the

sight of their social behaviour is always a

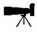

Related to the cormorant, the darter is blessed with a long serpentine neck that is ideal for the deft skewering of the fish upon which it feeds. Permeable plumage allows it to dive deeper than most birds and also explains why you often see it perched on a branch, drying its opened wings. As such, it is certainly one of the delta's most emblematic birds. The chances of getting this kind of shot are greatly enhanced by shooting from a boat using a long focus lens.

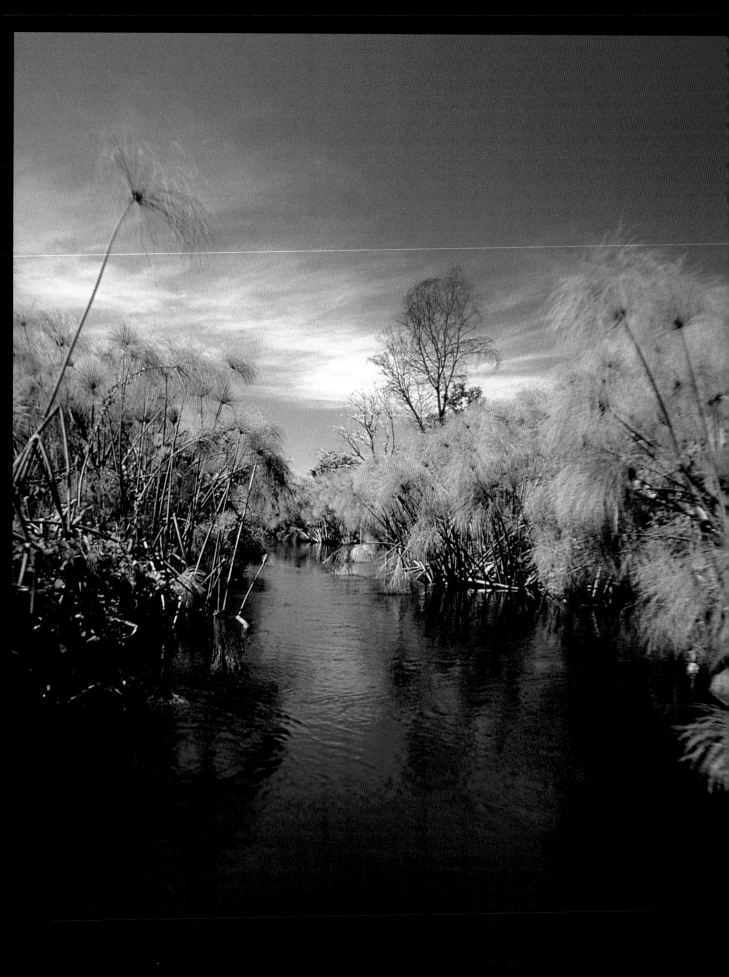

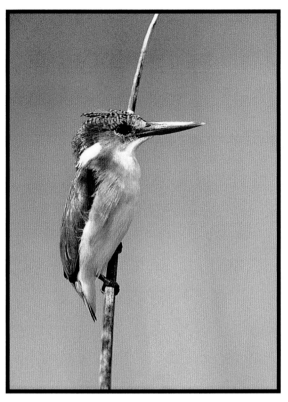

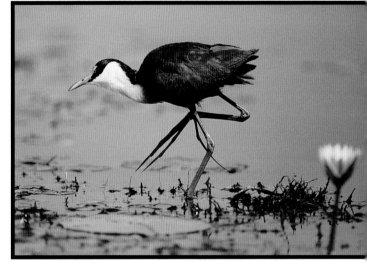

The African jacana is a curious bird, with a female having several male partners. Without further help from their mate, the male jacanas have sole responsibility for brooding and feeding the chicks.

Africa shelters numerous varieties of kingfisher. Of these, the malachite is undoubtedly the most beautiful. Endowed with extraordinary agility, it can stay motionless for hours perched on a branch waiting to seize a fish in its powerful beak which it then swallows whole. At the heart of the delta, it is advisable to approach birds by boat and to use a long focus lens which needs to be stabilised on a tripod or monopod. However, the narrow mokoro canoe, which is very typical of the available transport, makes it difficult to use most tripods unless one can be set up at a low level, such as the Benbo.

To capture the magic of silent waterways winding through papyrus, a wide angle or medium focal length lens are both appropriate. Light and handy, they can be your perfect companions for exploring the delta in a mokoro canoe.

source of great interest. Although living here too, predators like the hyena, lion or leopard are seen less frequently, the swampy terrain perhaps not so favourable for hunting. Occasionally, a couple of jackals make a furtive appearance. Fish, amphibians and reptiles – notably the Nile crocodile and the monitor lizard – are also well represented. But it is the 400 species of birds which especially reign supreme in this aquatic kingdom. The most visible of these are the African fish eagle, jacana, pygmy goose, reed cormorant, yellow-billed duck, darter, saddle-billed stork, yellow-billed stork and pelican as well as several varieties of heron, bee-eater and kingfisher. The delta also receives a multitude of migrating species that invade this region during the summer period when the severe winter prevails in the Northern Hemisphere.

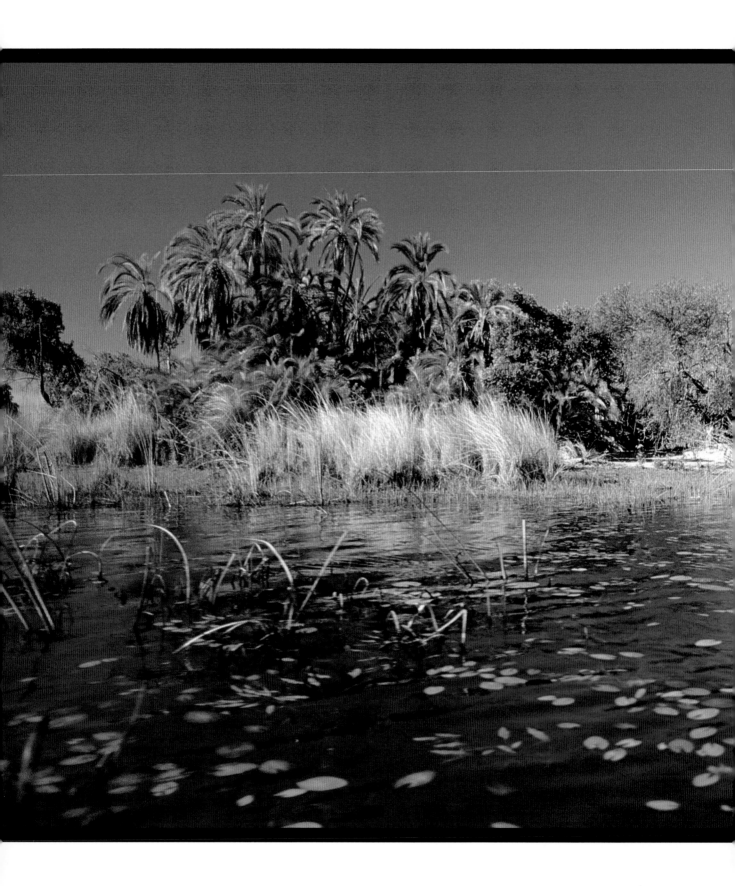

To photograph scenery, a wide angle lens is, as always, the most adaptable lens. It captures all the details of the location and gives ample scope for composing a shot where the objective is to absorb the richness of the environment, the profusion of flora and the shimmering harmony of colours.

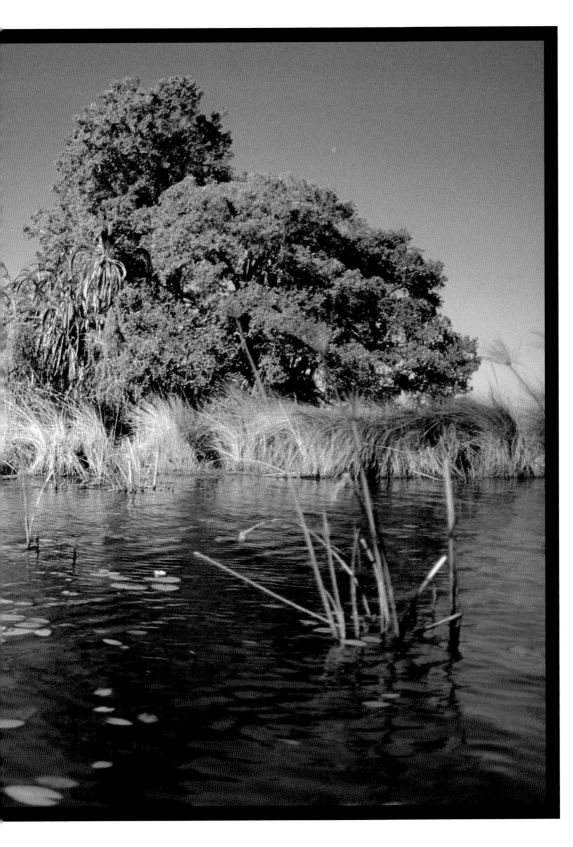

Reflections and sunlight falling upon a flower shows how plants can also provide photographic interest. Even by boat, taking a shot with the help of a medium focal length lens is not difficult. On the other hand, bee-eaters require the use of a long lens.

Very active in daytime, they are easier to approach in the evening. Frequently, they snuggle together in small groups to stave off the cold of night. This makes a wonderful opportunity to photograph them, by using a flash.

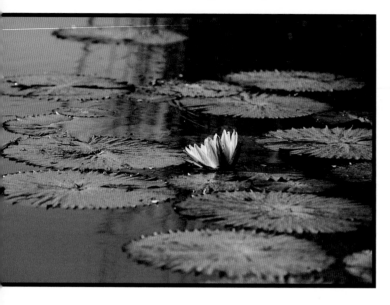

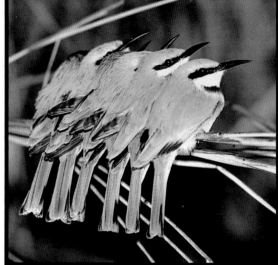

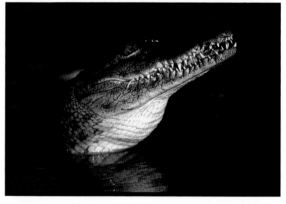

In this arid land of Botswana, the delta's precious waters have nurtured the development of more than 1,000 plant and tree species whose luxuriant vegetation is said to be seven times greater than the rest of southern Africa. The waterlilies, with their pale yellow and pink flowers, embellish the clear surface waters of the Okavango. Reed, papyrus and carex dominate the damp river banks, while on the islands a profusion of palm trees can be found surrounded by an undergrowth of grassy savannahs. Other trees which are commonly seen include willow, kigelia (better known as the sausage tree), acacia, marula, ebony and fig-tree. In summer, the lagoons provide an astonishing contrast to the

Capable of going several months without food, the crocodile feeds on anything – fish, birds or mammals. For the latter, it stays motionless in the water until the prey comes within reach and then seizes it in its jaws and drowns it by diving under water. Rather than getting too close, use a telephoto lens to take the shot. The same

caution is advisable with the hippopotamus, which is one of Africa's most dangerous animals. Only a telephoto lens will make a detailed shot possible. After spotting a favourite waterhole frequented by hippos, concentrate on anticipating the movement of one animal, then press the shutter release at the magic moment.

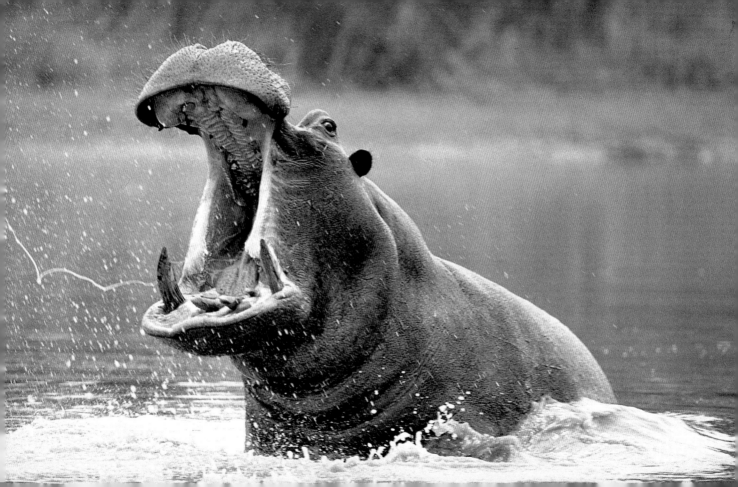

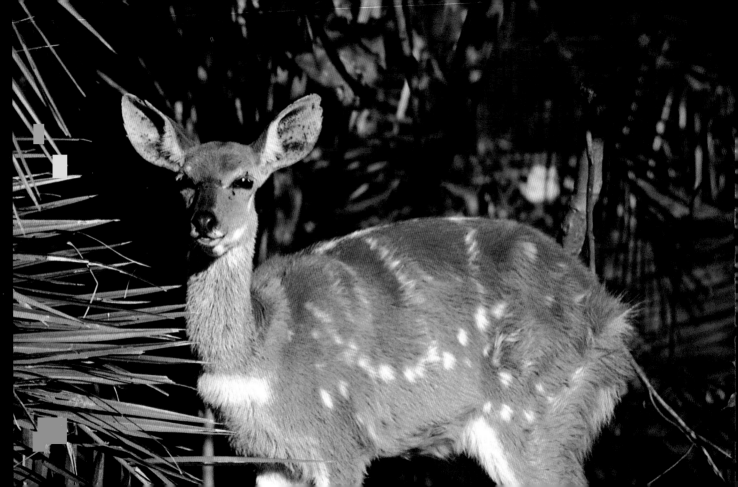

A solitary creature, the bushbuck is also shy and difficult to see because it tends to be active at dawn and dusk. It is particularly fond of habitats where dense vegetation hides it from sight so luck and discretion play a major part in capturing an image. In some circumstances, a medium focal length lens suffices to capture the encounter, as with this female. The key to success is to react gently, but quickly before it scurries away!

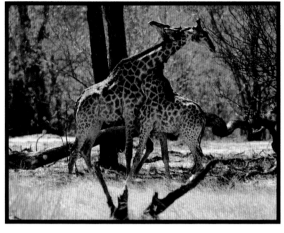

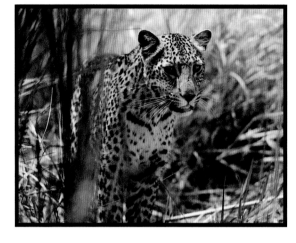

Giraffes are not territorial animals. But this doesn't prevent the males from engaging in ritual combat in order to dominate the very hierarchical groups which they form with the females. A long or medium length of lens, according to distance, should capture these movements which in many ways resemble a dance. However, there is no point in switching lenses to shoot the leopard. Most of the animals are not disturbed by the safari vehicles, but it is best to react quickly if an encounter happens because these felines are seldom seen. When they are, it is usually at nightfall as they prepare to depart for the hunt.

delta's most arid zone where thirsty mopane trees rustle in the breeze. Exploring the delta by boat is a marvel. While the sun penetrates every tiny recess, each bend or detour through the channels reveals a surprise – the calm of a crystalline lagoon inviting a quick (but prudent) dip; the flight of a bird surprised by the boat's movement; the siesta of a crocodile always on the look out for prey; the presence of a solitary elephant pushing through the papyrus. When dusk envelops this aquatic labyrinth, there are all the noises of the bush to regale campers' ears. The vegetation crumples under the footsteps of animals whose savage calls shatter the evening and feed the imagination of visitors blinded by darkness. The delta is unquestionably an oasis out of the ordinary; a place whose originality enchants and indelibly marks the minds of those who visit it.

Moremi

Following years of intensive hunting that reduced much local wildlife and brought certain species close to extinction, Moremi Reserve was founded in the early 1960s through the initiative of Chief Moremi III's widow and western ecologists. The only part of the Okavango Delta officially protected, even if the remainder of this remarkable ecosystem benefits from tacit protection, it covers a total area of 3,900 square kilometres and is sited in the delta's eastern quarter. With a juxtaposition of vast areas of dry earth and swamplands, the reserve displays a double form of wildlife. It subdivides into several precincts of which the four principal ones are: South Gate, Khwai, Xakanaxa and Third Bridge.

The total area presents an astonishing labyrinth of savannahs, forests, basins, flood-plains and lagoons whose abundance produces a habitat particularly well suited to supporting wildlife. It affirms Moremi's

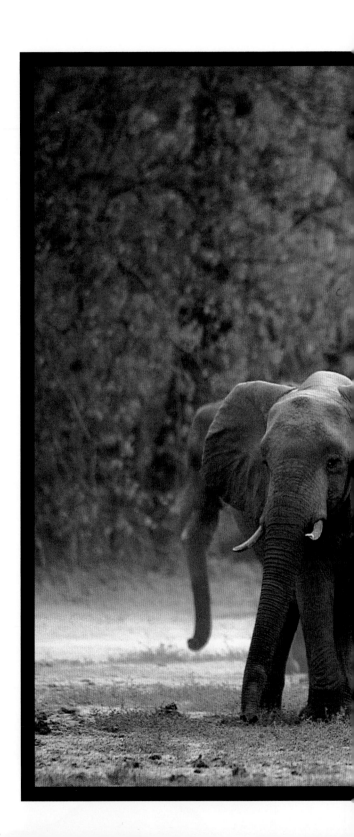

Elephant groups are usually composed of several females accompanied by their young. All the females are linked and dominated by a matriarch. Adolescent males leave the herd and sometimes cohabit with other bachelors. Upon reaching sexual maturity, however, they maintain relations with their matriarchal group.

Here again, it's a waiting game. The telling ingredients to this shot are the soft light and the silver rays of light caressing the elephants' ash-grey skin. A telephoto lens allows the photographer to keep a safe distance without disturbing the animals and avoids unwanted foreground clutter.

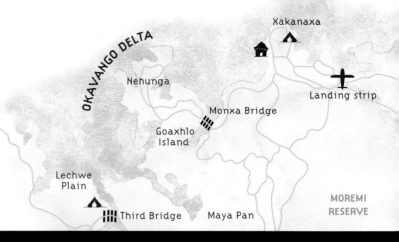

OKAVANGO DELTA

Xakanaxa

Nehunga

Landing strip

Monxa Bridge

Goaxhlo Island

Lechwe Plain

Third Bridge Maya Pan

MOREMI RESERVE

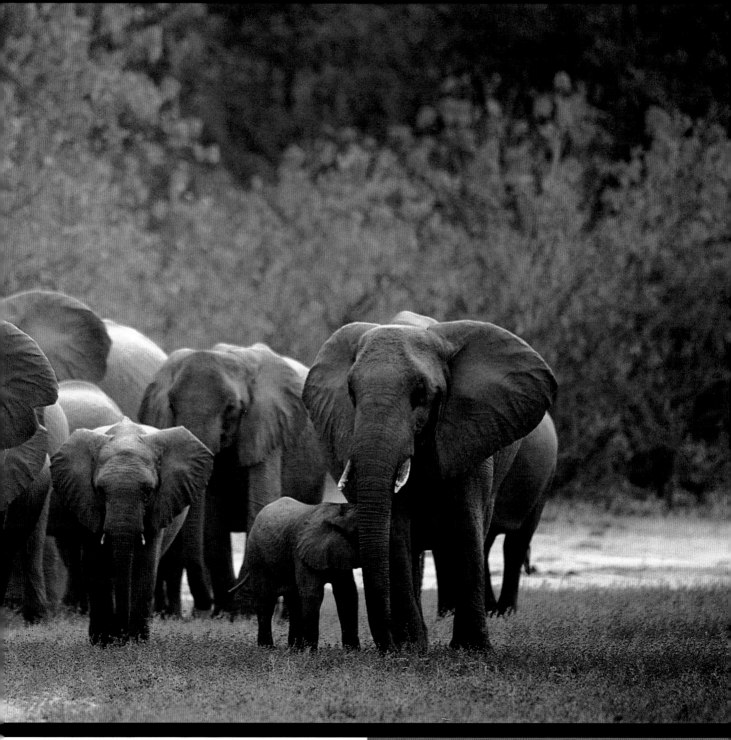

There are many different kinds of photographic composition and the best type of the light is not always what you expect. Trust your judgement. In this case, the sun was backlighting the lechwes with oblique rays filtered by the water plants, which enabled us to take this unusual shot of two lechwes. Native to the swamps and flood plains of northern Botswana, this antelope never strays more than three kilometres from a permanent waterhole.

A consummate swimmer it mainly feeds on water plants. The water not only acts as its larder but also offers a refuge when the animal feels threatened.

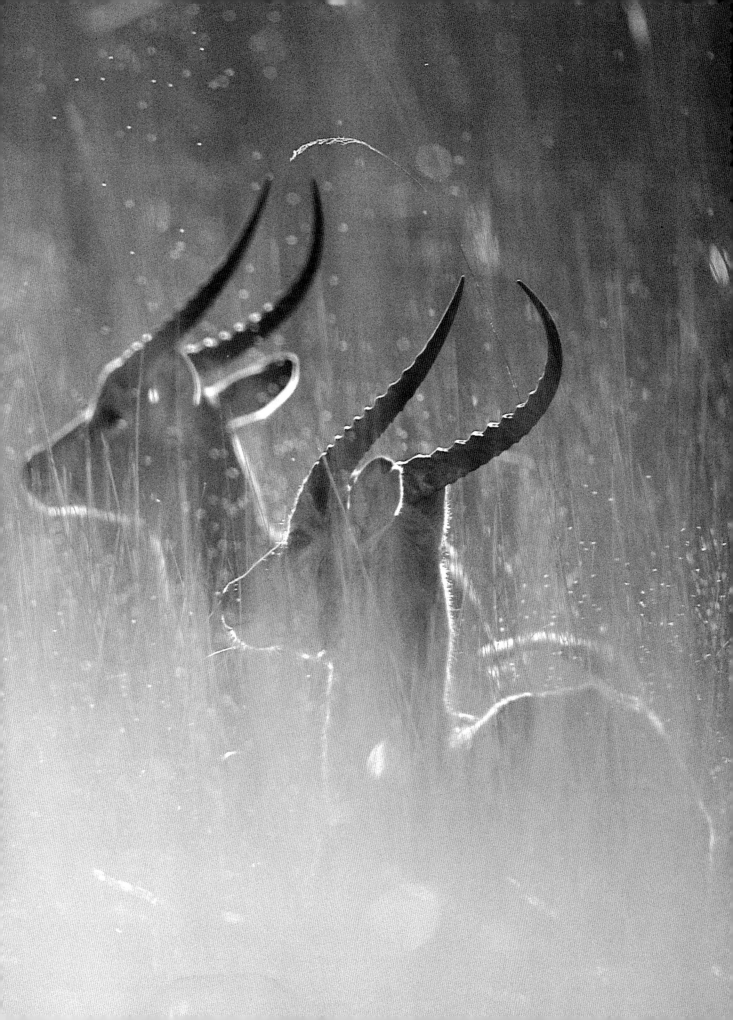

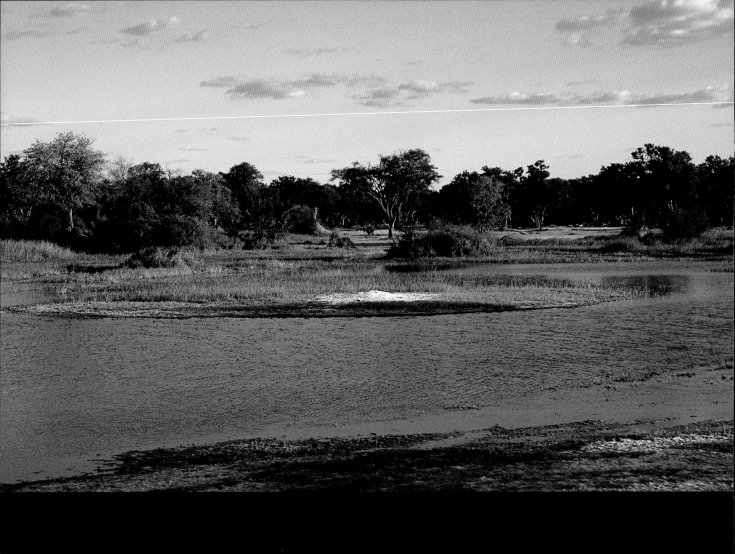

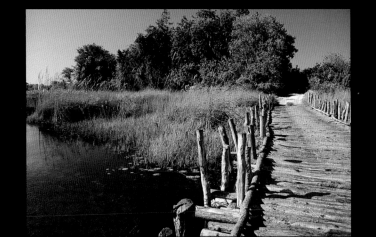

Impalas are gracious antelopes that live in large groups, the males on one side and the females and young on the other. These exclusive groups break down into harems during the rutting season, and then reform during the gestation period. Their timid nature makes them difficult to approach and a long focal length lens is needed to photograph them especially if, as is seen here, you wish to capture the luminous quality of soft backlighting.

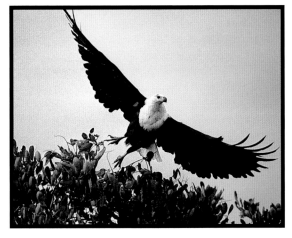

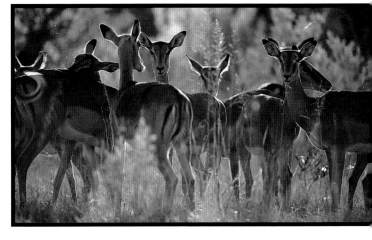

Reacting quickly to a given situation is fundamental on safari. Animals are swift, so always be ready to shoot, like here, the flight of a fish eagle. This is one of the most common birds of prey seen around lakes and rivers, where it finds the essentials for its survival. A long lens well supported, is indispensable to ensure the bird appears sharp and a reasonable size within the frame.

Photographing scenery is not only a way of recapturing the mood of a trip but also the locations visited and the environment in which the animals exist. In the shot (top left), of one of the countless channels that furrow the Xakanaxa precinct or the log bridge at Third Bridge (bottom left) they achieve just that.

claim to having the delta's largest concentration of animals and, in addition, to being among southern Africa's most beautiful reserves! Along the edge of the flooded plains, large forests of Mopane trees typify the South Gate vegetation. This tree, widespread throughout northern Botswana, with leaves like butterfly wings, takes on a more bushy form due to the soil's lack of nutrients and intensive elephant feeding which prevents the normal growth of trees. Apart from numerous elephant herds, the impala, kudu and baboon are other species frequently found in this woodland setting. It is equally prized, among others, by the hoopoe and several varieties of hornbill. Wonderful but shy, the sable antelope and the roan antelope can be photographed at a reasonable distance. But the animals can sometimes be difficult to locate under cover of the vegetation and the proximity of a waterhole does, understandably, help.

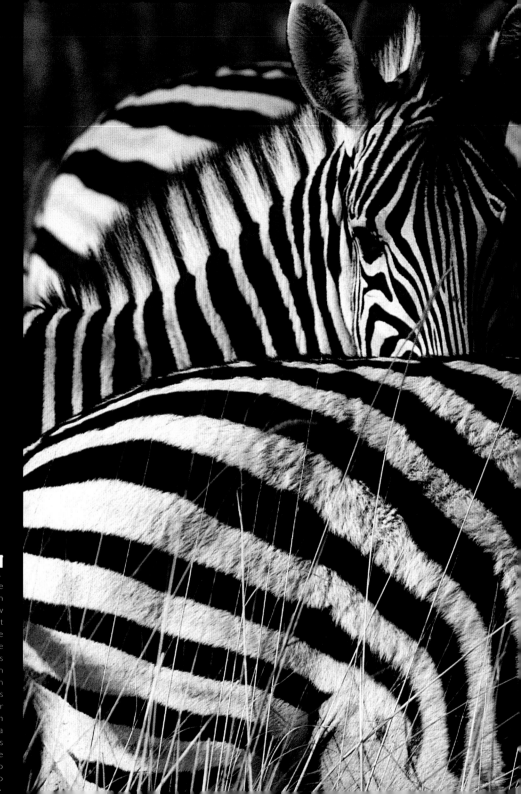

Safari photography presents the opportunity to experiment with different shots, or to research new effects. Black and white is not usually associated with wildlife photography but offers the opportunity to explore new kinds of picture expression. Through contrast and the play of light on their coats, these close-knit zebras were not to be missed. Their gregarious character brings them into groups composed of a dominant male, several females and their young. Other groups are formed by stallions too young to found their own harems or too old to dominate any more.

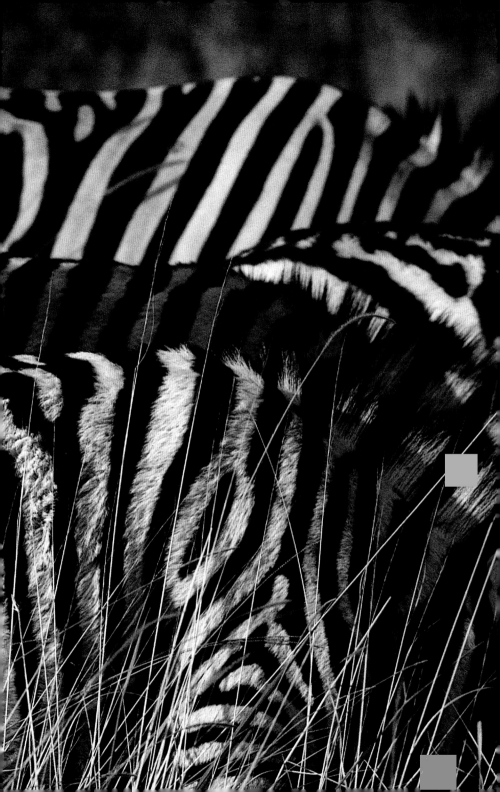

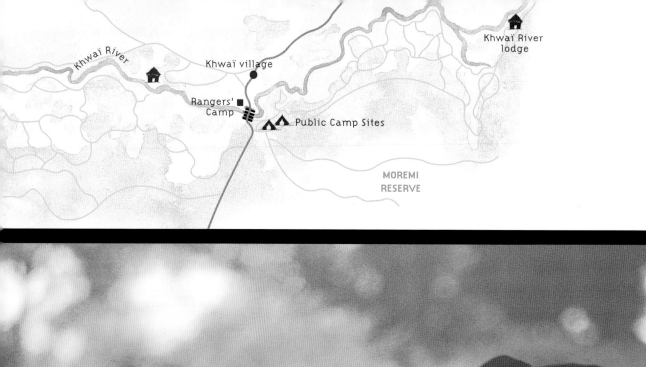

Khwaï River

Khwaï village

Khwaï River
lodge

Rangers'
Camp

Public Camp Sites

MOREMI
RESERVE

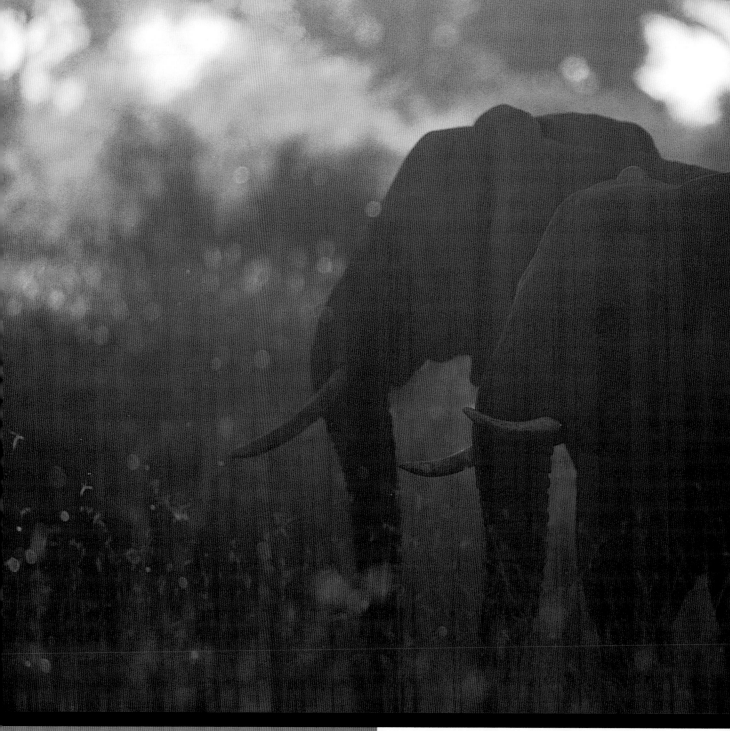

Photographing a static scene makes it even more important to master composition and light so that the shot is original. A long focus lens is essential to concentrate the light and delineate the elephants in the backlight. The same equipment will help to capture the fleeting gesture of jackals at the end of a frolic over a piece of meat. This lucky shot depicts an intimacy of two jackals whilst feeding on carrion, before vultures and other predators move in. This small opportunistic canine hunts on his own, but will also fight vultures and other predators over carrion.

It is possible to encounter zebras, warthogs and perhaps – if you are especially lucky – a solitary leopard or even a pack of wild dogs. Thirty percent of Africa's population of wild dogs are thought to live in Botswana, mostly around Moremi. The saddle-billed stork and the wattled crane are also a frequent presence at permanent water holes around which they feed, often under the impassive gaze of crocodiles. North of the reserve, the Khwai River lends its name to this corner of Moremi. It constitutes one of the delta's numerous ramifications and carries water to the heart of the region which, without it, would be desert. Khwai embraces a variety of settings; flood

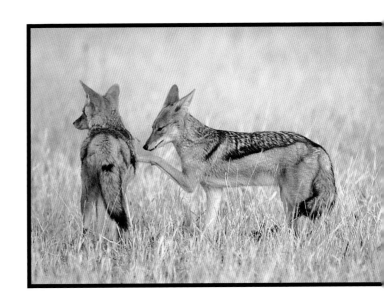

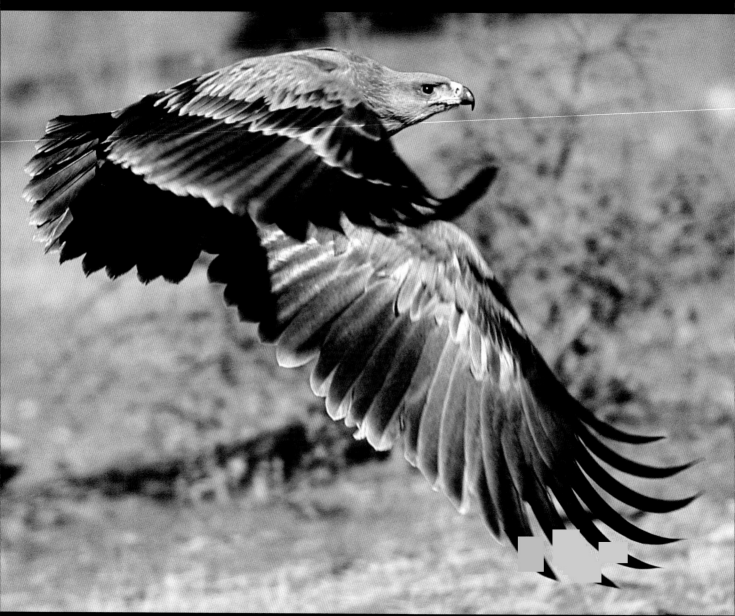

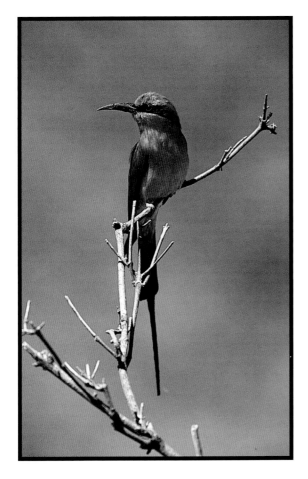

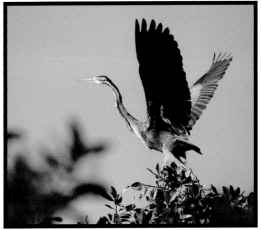

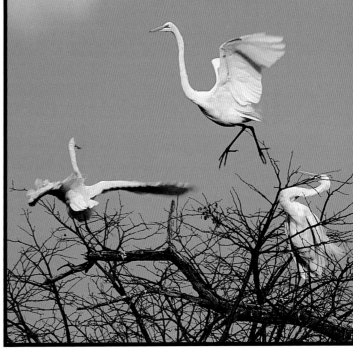

plains shaded by riverside woodlands; acacia and sycamore islands surrounded by marshes; and grassy savannahs punctuated by the outline of mopane trees stunted by elephants' voracious appetites. Innumerable termite mounds break the skyline here and there, said to provide Moremi's best safaris, Khwai protects an abundance of wildlife. In addition to common African animals, the presence of water attracts sizable elephant, hippopotamus and crocodile populations. Important colonies of aquatic birds move around in this mixed ecosystem, but above all Khwai is noted for its huge concentration of birds of prey, including a remarkable variety of eagles: the martial eagle, tawny eagle, bateleur, fish eagle and steppe eagle amongst them.

This tawny eagle feeds on carrion and is capable of protecting a carcase against several vultures. The goliath heron – largest of all the herons – spends half the day hunting and sometimes catches a fish weighing half a kilo. The great white egret even hunts after dark in the moonlight. Nothing but a long focus lens will do when photographing these birds. Catching a bird in flight is difficult and anticipating their movement and direction is not simple. For the carmine bee-eater, a teleconverter is a useful accessory. This tiny bird loves insects which it captures in flight. It will even remove a bee's sting or its venom before devouring it.

In the west of Khwai, Xakanaxa is the name of a magnificent lagoon to the east of the Moremi Peninsula. A universe of mysterious ponds and peaceful lagoons lost amongst reeds and forests of giant trees reaching into the sky and of savannah with undulating blond and purple grasses, Xakanaxa undoubtedly has Okavango's finest scenery. The vegetation in the delta's south is again dominated by mopane trees, while water plants have colonised its protected channels and waterhole margins. In Xakanaxa, wildlife is omnipresent but elusive and sometimes difficult to find. As well as herbivores like elephant, buffalo, antelope, impala, zebra and their predators, Xakanaxa also boasts one of Africa's largest heronries and an abundance of other bird species such as ibis, duck, egret, cormorant, kingfisher, bee-eater and plover. Third Bridge is the delta's third largest island after Chief. It is also a picturesque log bridge which spans the Sekiri River at a spot boasting a wonderful lagoon, fringed by reeds and papyrus. The limpid waters are a timely reminder of the presence of crocodiles. Third Bridge is one of

Early in the morning the sunlight which embraces nature, guarantees the best contrasts for a shot. The warm colours are saturated, the details elaborate. It is enough to capture the cat's golden appearance through the shrubs — preferably with a long focus lens for a more thrilling portrait.

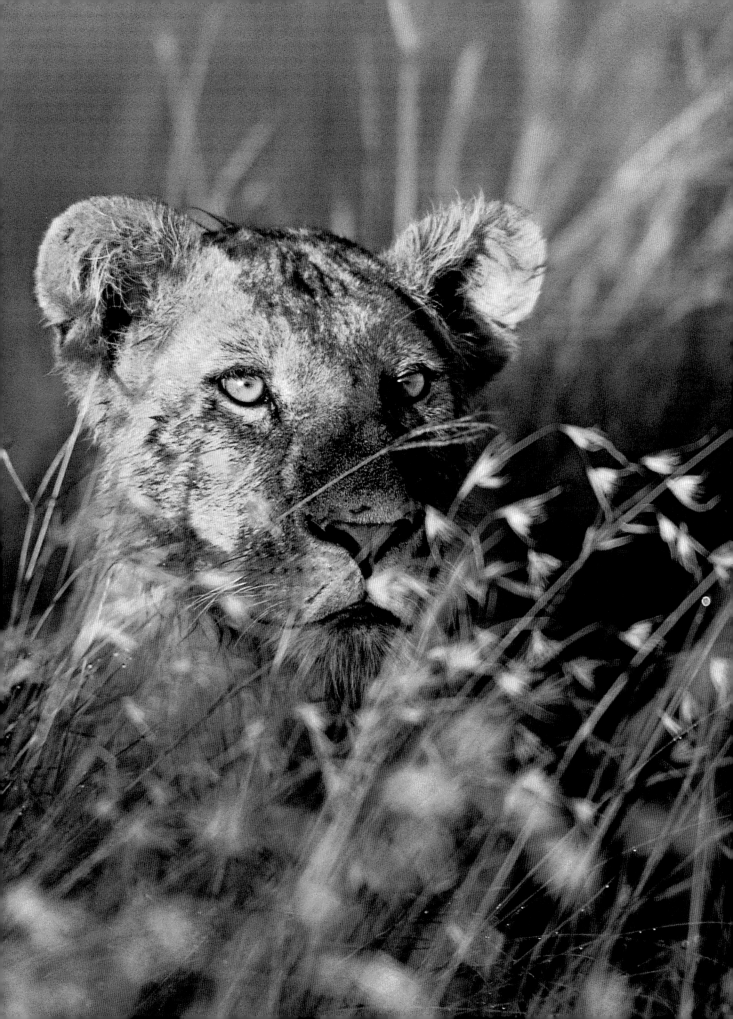

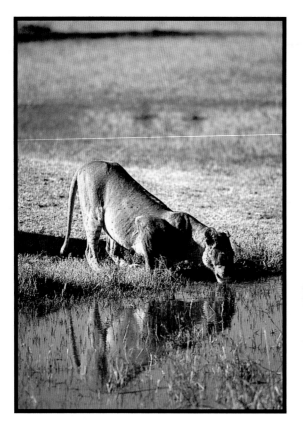

Even with the sun at its zenith, it is possible to take photographs. Of course, the harsh light provides a reduced palette of contrasts, but this can be exactly the time of day when animal encounters are fruitful. It is not uncommon, for example, to witness the flight of a wattled crane or a lioness slaking her thirst after feasting.

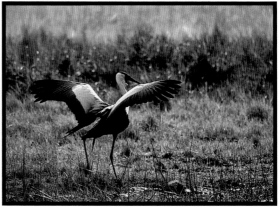

It is relatively rare to see the wattled crane. This superb wader is, in fact, an endangered species. It generally lives in pairs but male birds sometimes form exceptional groups of up to 50 individuals. Lions, meanwhile, prefer to rest in the shade during the hottest hours of day. Indeed, they spend up to 20 hours a day sleeping. This lioness has had her fill of a lechwe she hunted in the morning and is now quenching her thirst before resting.

the few places where the vegetation is not dominated by mopane trees, and the sunlight penetrates the forest cover as it passes through acacia, sausage tree and marula leaves. Elsewhere, the scenery changes to open savannah, which makes it easier to observe wildlife such as buffalo, elephant, jackal, vervet monkey and a large number of antelopes including the lechwe, waterbuck, and impala, without forgetting the greater kudu. Lions, on the other hand, often make use of the main path that crosses the river and continues to South Gate. Like everywhere else in the delta, the birds live in great numbers around Third Bridge. The scenery, together with the bountiful wildlife, make Moremi an absolutely essential stopping place on any visit to Botswana.

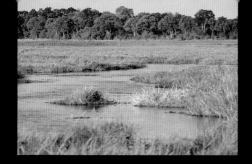

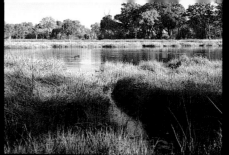

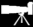

The tongues of land saved from the delta's waters afford some marvellous havens for large species of fauna. It gives the photographer a multitude of possibilities to shoot, with wide angle or medium focal length lenses, images that will capture the mood of the sites visited, such as this one on the River Khwai.

Sometimes luck offers the opportunity to witness and photograph the very rare wild dog, a canine that lives within a clan organisation similar to that of the wolf. Hunting in packs, it is not scared to attack prey much bigger than itself. To capture an encounter with this fascinating animal, a long focus lens is necessary.

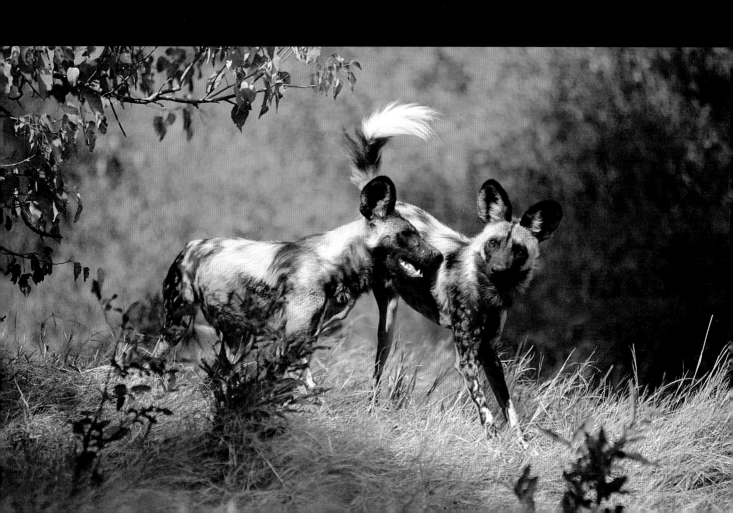

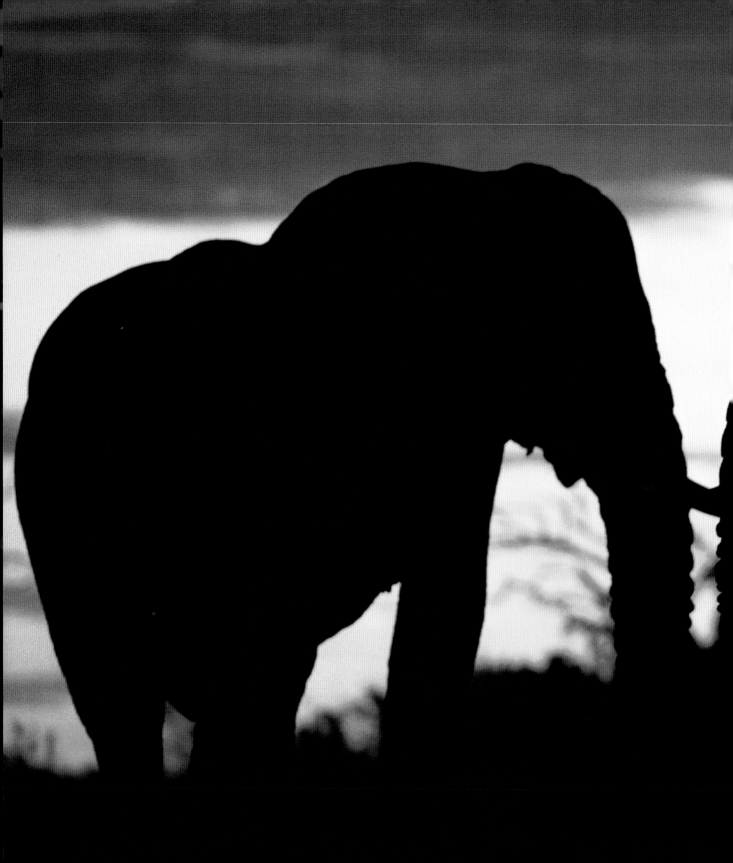

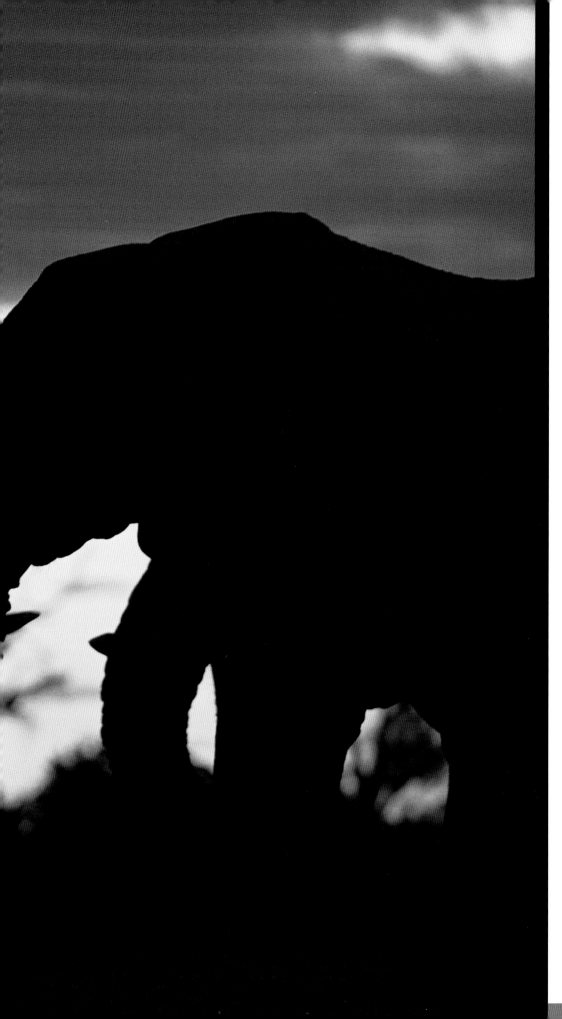

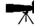

Meeting with elephants always is a fabulous experience. These fascinating creatures not only communicate by trumpeting but also by infrasonics, which can be transmitted over distances of several kilometres. In this way they are able to inform each other about water and food sources. Water holes are privileged places. The animals take their turns, offering numerous opportunities to the photographer, who has to act quickly, when the fading light helps to shape a silhouette so exquisitely.

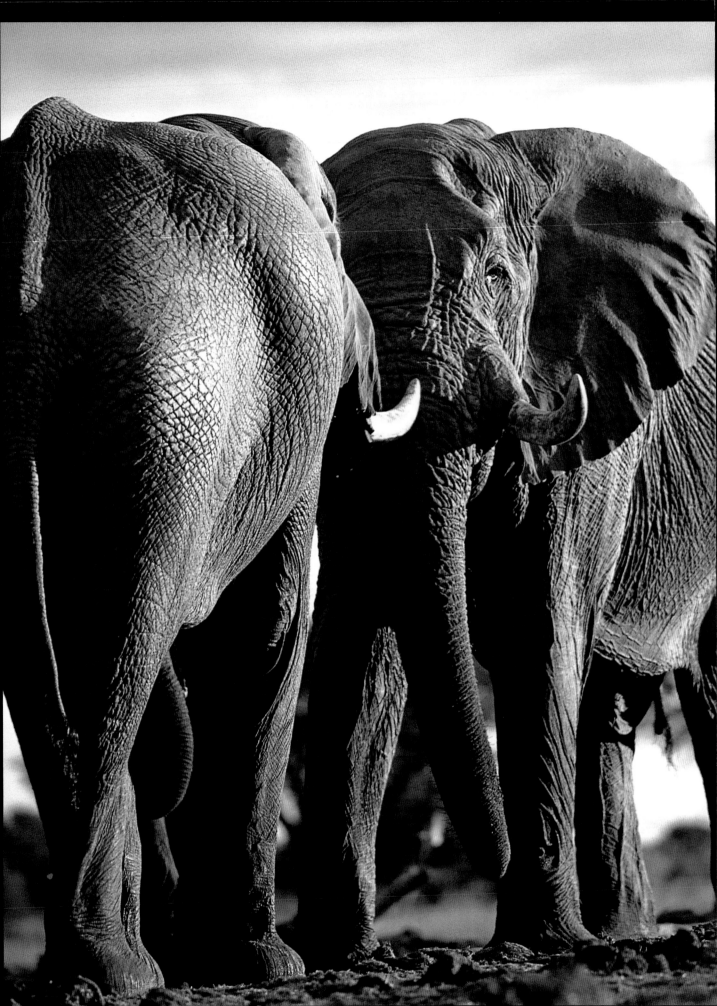

Savuti

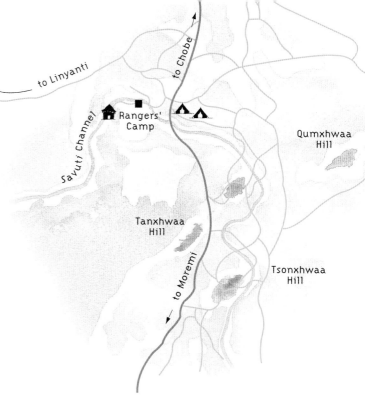

Long ago the Savuti region was submerged under the waters of the immense Lake Makgadikgadi, which then covered most of the country. As a result of tectonic movements and climatic change, however, it dried out and is today little more than an arid, flat depression. To the northwest of this depression are the Savuti Marshes, within Chobe National Park territory, halfway between the edge of a river of the same name and the Okavango Delta. Covering an area of 110 square kilometres, it is fed by the Savuti River which rises in the Linyanti Marshes to the north. But this is a phantom channel whose unpredictable flow can cease for several years, then resume for no apparent reason regardless of rainfall.

From their earliest years onwards, male zebras play and confront each other. When the time comes to form harems, however, serious combat ensues. Stallions violently bite and kick each other until one or other prevails; so zebras are not the calm creatures that one sees grazing peacefully on the savannah. Like Tanzanian wildebeest, they also migrate in search of fresh pastures. On safari, therefore, it is important to find out about the habits and seasonal movement of animals in order to pinpoint the best viewing spots. For example, knowing the Savuti zebras' migration route offers the chance to combine the sun's best position and direction to improve the quality of photography.

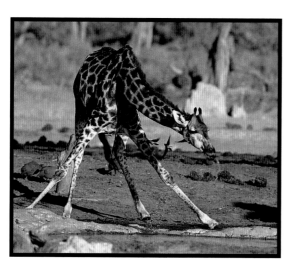

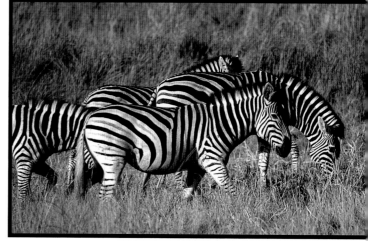

With a height of 5.2 metres and weighing up to 1.4 tons, the giraffe is a vulnerable creature, particularly at waterholes. It approaches such places very slowly, observing the surroundings for a considerable time and with great caution before bending to drink. Therefore, a long focus lens is best for giraffe shots as, indeed, it is for this peaceful head-to-head picture of two elephants bathed in the final light of day. The low-angled shot from ground level reinforces the monumental character of these animals.

Reflections of a dying day – the blazing sky wedged between a forest of shadows and leaden clouds just prior to a spectacular moon rise. A medium focus lens is ideal for capturing this moment of intense luminosity. But a telephoto lens is better to capture a picture like this one of two cheetahs and the fluid shape and symmetry of their bodies. The ensemble is enhanced by an evening sun that spotlights the animal faces.

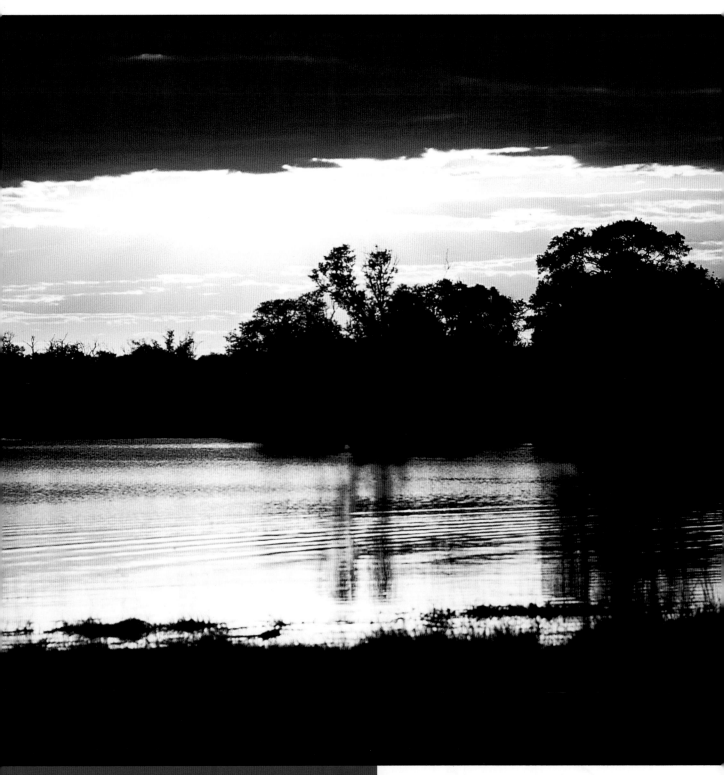

Today, the marshes are dry, the channel's course having been mysteriously interrupted in the early 1980s. Scientists assume that the phenomenon is due to very low intensity earthquakes that frequently shake the area. Despite this lack of a permanent water supply, the Savuti countryside – austere and wild – is nonetheless an important animal sanctuary for herbivores and predators alike. For animals, the region is a favoured stopover because it possesses the only dependable waterholes, some of which are artificially fed by the park authorities, between the Okavango Delta and the Chobe River. During the dry season, therefore, the wildlife congregates around these vital water sources.

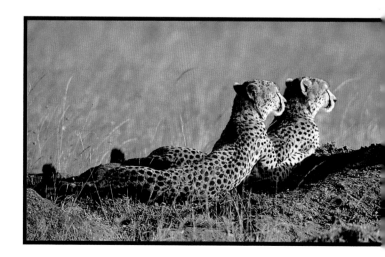

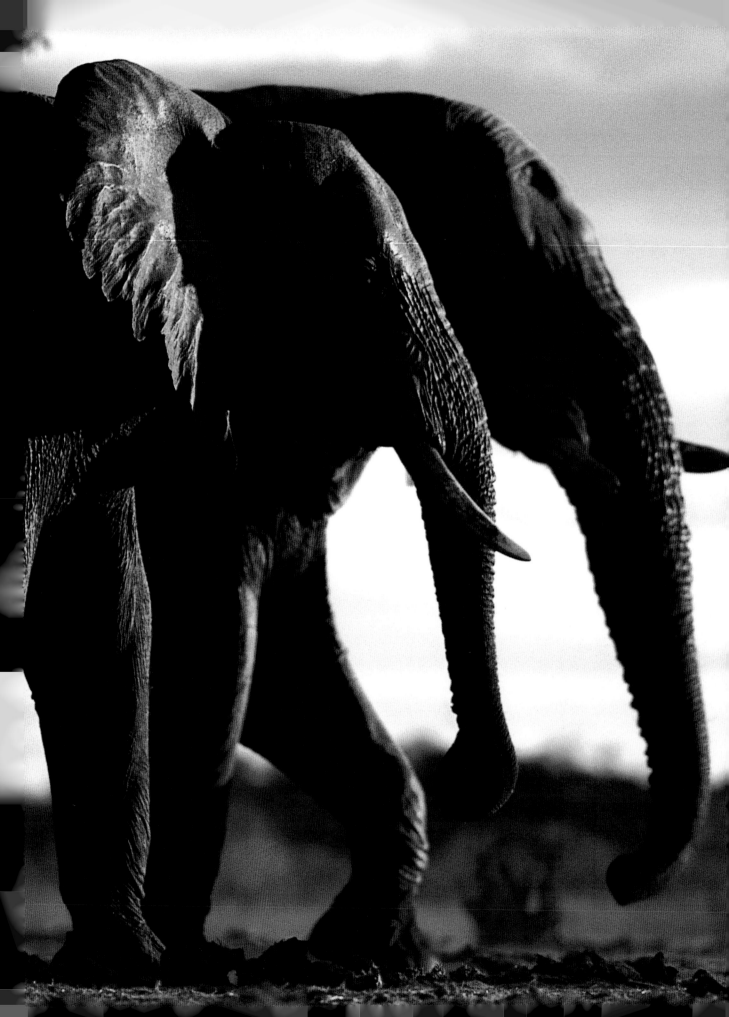

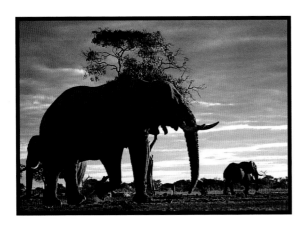

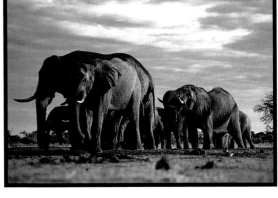

Although Savuti is renowned for its groups of spotted hyenas and lions, as elsewhere in Botswana many elephants are also present. In late afternoon, entire herds colonise the waterholes, tolerating the presence of other animals according to their mood. Out on the vast yellow plains, in the eerie shade of trees that died because of the drying of the marshes, it is not unusual to spot cheetahs. Savuti is also the largest known site for zebra migration. Each year around November, when the rains transform the marsh vegetation into a green and flowering savannah, zebra herds begin to arrive, totalling up to 25,000. They are often accompanied by blue wildebeest and by tsessebe who, in turn, are followed by the main predators for whom their gathering is a windfall.

Then around March, when water gets scarce, herbivorous zebra and wildebeest head for the Linyanti swamplands in the northwest. Located on the route linking Moremi with the river banks of Chobe Park, Savuti holds some excellent surprises in terms of wildlife sightings.

In the presence of a group of elephants, the best photo opportunities will be gained by lingering to watch their behaviour, so as to anticipate their movements. It is also not a bad idea to use several different lenses to take pictures from different angles as with this ground shot. This is an ideal way of illustrating the gigantic proportions of elephants. An added bonus is when the setting sun illuminates these moments plus, of course, the actual thrill of the encounter.

An elephant can drink up to 10 litres of water through its trunk, which it then either blows into its mouth to quench its thirst or onto the body to cool itself. During dry periods, some even regurgitate water from the stomach to spray themselves.

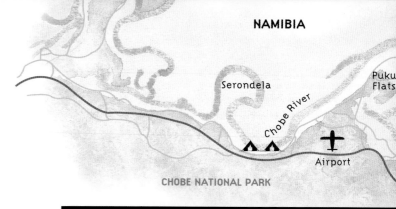

NAMIBIA

Serondela

Chobe River

Puku
Flats

Airport

CHOBE NATIONAL PARK

Chobe

Chobe National Park is located in northeast Botswana, close to Kasane at the convergence of four national frontiers: Zambia, Zimbabwe, Botswana and Namibia. The concept of creating a vast protected territory dates from the 1930s when the country was still called Bechuanaland. But it took another 30 years before a part of this region was officially protected, just prior to the National Park's establishment in 1968 over a much larger land area. As the country's third largest sanctuary, Chobe extends over almost 11,000 square kilometres and sub-divides into various wildlife reserves. It takes its name from the river, which marks its northern border with the Caprivi Strip in Namibia. Just like the Okavango, Chobe rises in the high, wet plateau of Angola. Initially called the Cuando, the river changes its name according to the country and region through which it is passing.

A familiar silhouette reflected in a silver mirror of water at a moment when the sun has already disappeared behind the horizon. A medium focus zoom lens produces a strong graphic shot with just enough subject matter and environment to capture the mood of the setting.

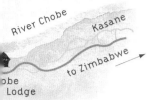

River Chobe
Kasane
to Zimbabwe
obe
Lodge

An elephant consumes between 70 and 90 litres of water a day. In dry periods, they are sometimes obliged to bore dried-out riverbed hollows to reach subterranean water courses. Their tusks and trunk, therefore, are precious tools.

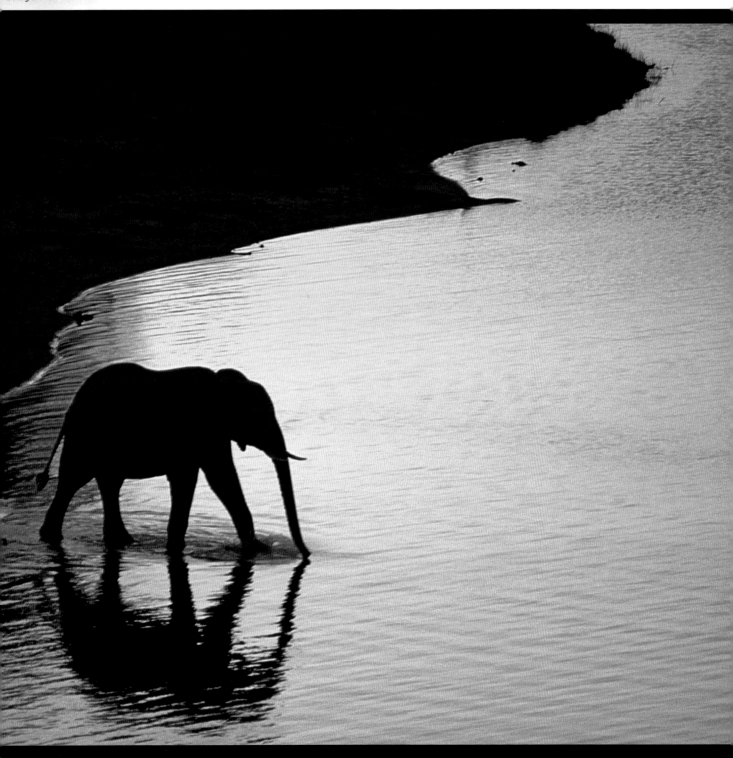

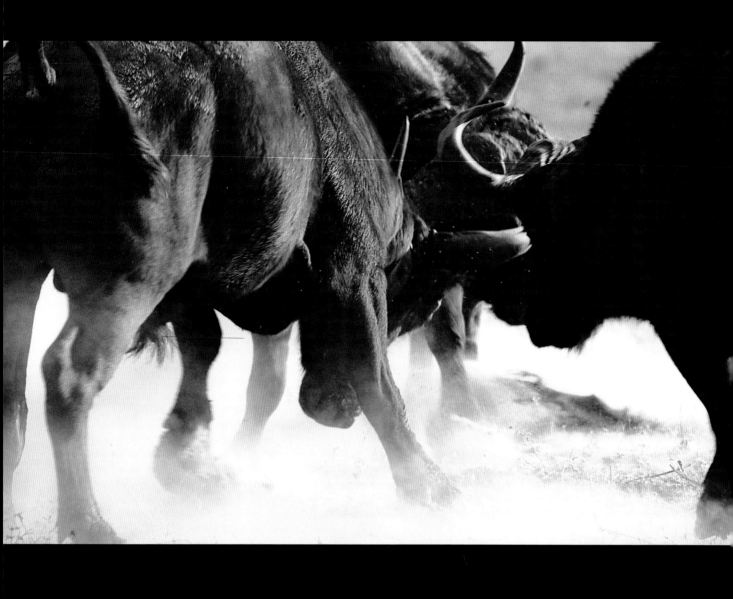

It is variously named Kwando, Mashi and Linyanti before finally becoming the Chobe in Ngoma. Its course is generally parallel with that of the Okavango until the latter bears south. Its route is determined by a complex system of faults – a continuation of the great East African Rift. At the end of its course, the Chobe used to flow first into the Limpopo and then into the Indian Ocean. But movements in the earth's crust have altered its journey, which particularly explains the formation of swamplands like those of Linyanti. Today it joins the Zambezi at Kazungula. At this point a hydrological phenomenon occurs which is probably unique in the world. When the waters of the Zambezi attain a certain level, they reverse the flow of the Chobe. This river is the foundation upon which an ecosystem protecting one of the African continent's most important wildlife concentrations is built. The park's fame stems from large populations of buffalo and elephant. In a country short of water, its dependable presence produces some striking contrasts. Thus, it is not just a few herds of hefty elephants that elect to live here, but tens of thousands. Some undertake a seasonal migration of 200 kilometres, which leads them to the southern plains where they go their separate ways in the rainy season. Chobe elephants also have the distinction of being considered the largest of Africa's elephants. But most of the time their tusks are shorter than that of their East African counterparts because the soils of the Kalahari, whose basin covers most of Botswana, are poorer in nutrients and minerals.

A census of Botswana's elephant population puts the figure at almost 120,000, of which about

Crossing the path of a buffalo herd is always impressive, especially when you appreciate that this imposing bovine and the hippopotamus compete for the title of Africa's most dangerous animal. When it confronts another buffalo, the combat violence is spectacular and necessitates a long focus lens, not only to isolate the shot and capture the enormous strength and energy of these animals, but also for obvious reasons of safety. It is worth stressing that Botswana's light really does possess a distinct beauty, as can be seen here.

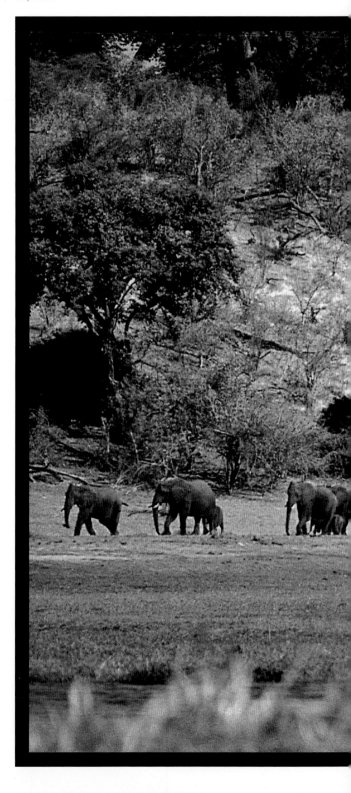

71,000 live within Chobe National Park. This represents the highest density per square kilometre throughout the continent. Their gatherings along riverbanks are quite compelling. They provide wonderful photographic opportunities especially when angled sunlight reveals their rough hides. Buffalo, on the other hand, are slightly less numerous but it is not uncommon to see herds of several thousands. It is at Serondela in the park's northern extremity that the wildlife converges, notably the elephants whose gatherings are the most spectacular. In the evening, just before the warming rays of the sun fade, all animals from the nearby forests come to drink from the river. Hippopotamus, which have passed the day immersed, take their place alongside the greater kudu, impala, giraffe and also the warthog, mongoose, baboon and many others besides; including the famous sable, a superb antelope whose ringed horns can

Despite being two to four centimetres thick, an elephant's skin is sensitive to sunlight and parasites. This is why an elephant, therefore likes to bathe, massage and smear itself in mud as often as possible. If the waterholes fail to provide enough of this precious plaster, the elephants, with the help of their tusks, churn up the ground at the water's edge, which they pulp into a muddy paste for anointing themselves.

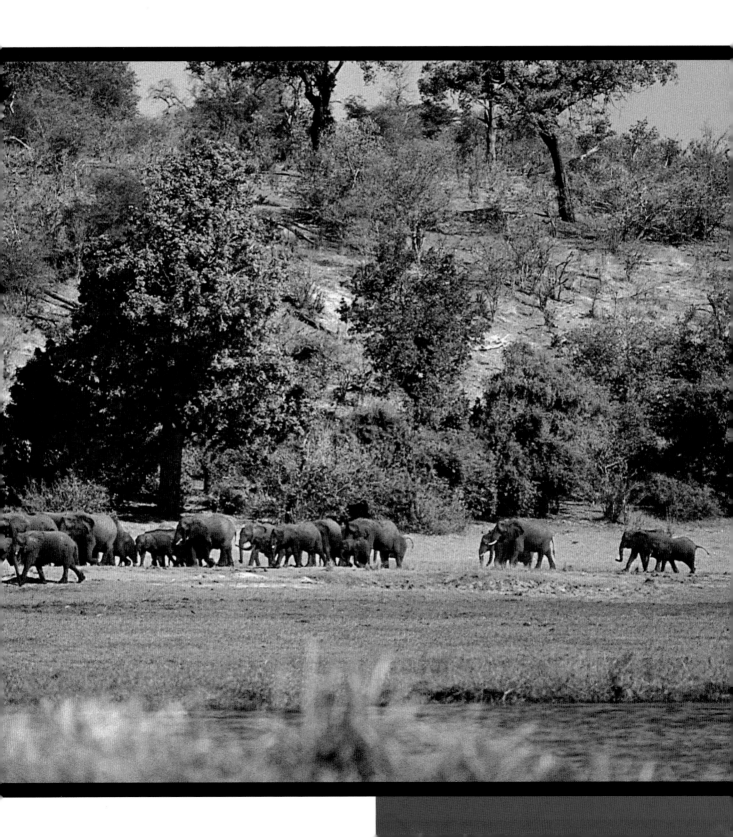

This large stork with the two-toned beak and peaceful demeanour is the saddle-billed stork. However, this bird is vindictive towards anyone that steps inside his fishing grounds. Intruders are chased away through a merciless combination of feverish running and beating of wings. The grey lourie on the other hand, is a bird found throughout Botswana. The wooded savannahs and scrublands are its preferred habitat, which does not extend into more arid areas such as the Kalahari Desert.

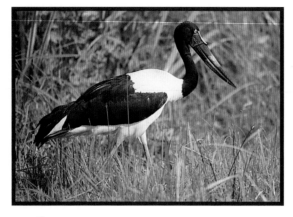

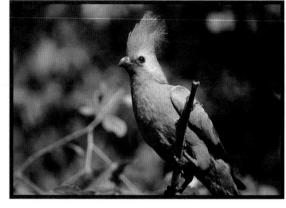

Since most birds are timid by nature, the photographer must be both discreet and swift. A telephoto lens needs to be well stabilised on a beanbag, if travelling by car; or fixed to a monopod or tripod for full-frame close-ups taking care not to disturb the animals you want to photograph.

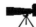

During the dry season, positioning yourself close to waterholes is the best way to observe the park's abundant wildlife. The more social animals, such as the elephant, always provide the most interesting behaviours. For close-up shots, like the one opposite, a telephoto lens is recommended due to the presence of young and parental protection.

be over a metre long. Rare and shy, it is nevertheless quite common to see this animal close to this watercourse because these antelopes come to drink at the river at the same time every day (and usually around the same place).

Such profusion of wildlife does, of course, attract the big cats – lions, leopards, cheetahs – without forgetting other carnivores and carrion eaters like hyenas and jackals. The presence of these predators does not, however, offset the over-population of herbivores in certain parts of the park and the unfortunate consequences for the environment. The bird population, meanwhile, encompasses some 450 species, notably represented by the splendid African fish eagle. The latter is quite easy to see although its distinctive presence does not upstage that of waders like the saddle-billed stork, open-billed stork, yellow-billed stork and great white egret. The hamerkop, southern yellow-billed hornbill, Egyptian goose, go-away bird,

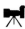

Running through the centre of an enormous forest massif, the Chobe River is one of Botswana's main sources of dependable water and explains the presence of so many wild animals. Wonderful encounters may occur whilst patrolling the banks by car or boat, preferably in the morning or evening to guarantee best light and atmosphere. The closeness of some animals, like this baboon, allow the use of a medium focal length lens.

Baboons are a gregarious species that live in groups in which only the dominant males mate with females that are on heat. Subordinate males must be satisfied with younger, less receptive females. It is only when they're about five years old that the junior males assume dominant roles. When the group is foraging for food – typically roots, insects or berries – a male or sometimes a female is posted on a high branch to keep guard, and to be ready to sound the alarm.

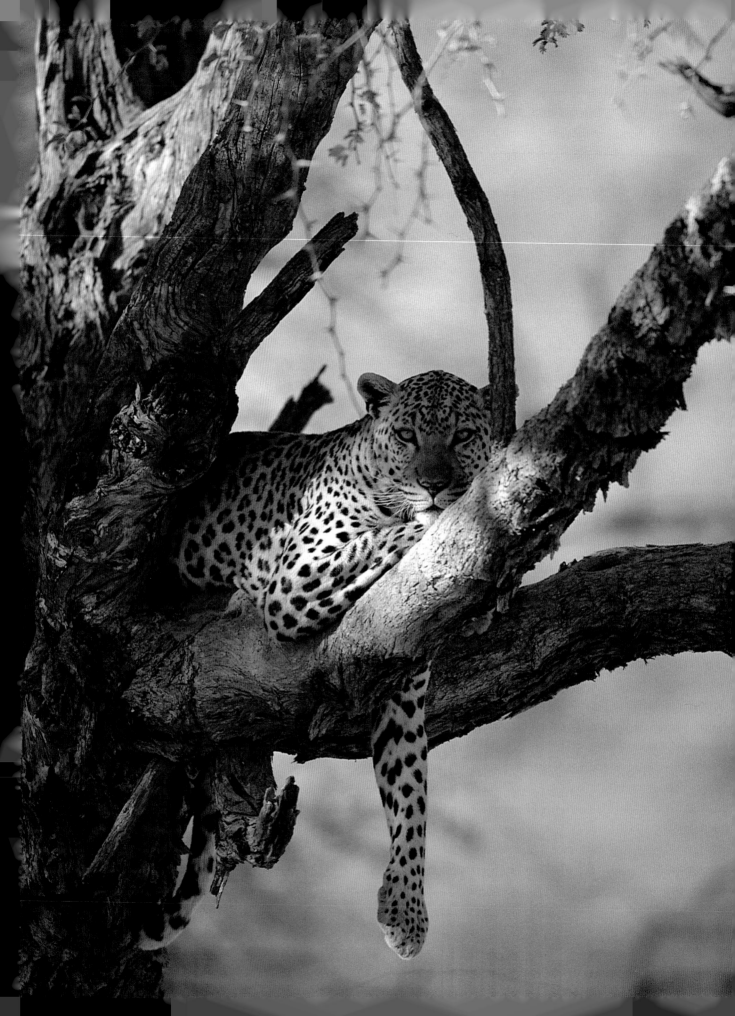

The best photographs are taken in the morning and late afternoon. The warm, fading rays of sunshine highlight subjects and are essential to the quality of a shot. But, for the occasional safari traveller, who wishes to bring back a photo souvenir or record a wildlife encounter, it may mean foregoing the golden rule and photographing at other times of day. As always, though, the use of a long or medium focal length lens is preferable.

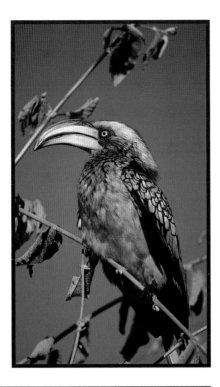

The yellow-billed hornbill is widespread throughout Botswana. As an omnivore, it feeds equally well on berries and insects as well as on small animals, rodents or reptiles. Somewhat opportunistic, it often fearlessly approaches campsites in the hope of gleaning food. The sable antelope has arabesque horns measuring more than 80 centimetres. It lives in wooded areas where food is plentiful and where it can hide. The male's coat is black, the female's more russet.

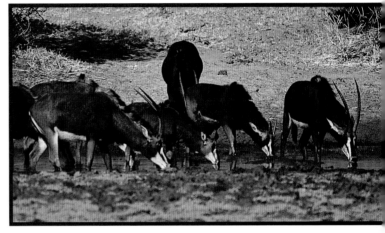

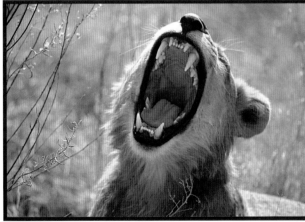

To find oneself in the company of a leopard is almost a miracle! Often perched in trees, where it habitually drags prey to avoid losing it to other predators, the leopard is actually not very shy. Long and medium focal length lenses can be used to capture such a meeting, which is unlikely to happen too often.

lilac-breasted roller and pied kingfisher are only some of the many residents of the park. At daybreak, hundreds of birds – such as the pelican or the white-faced duck fly over the still waters of the river in a blast of air. The fertile soil of northern Botswana accords the Chobe region vast areas of forest where trees enjoy more or less normal growth. Mopane trees dominate this wooded space but the distinctive branching baobabs are also part of the scenery, which, in summer is dotted with yellow gardenia flowers and the mauve flowers of Rhodesian Teak. Mahogany trees are plentiful along the banks of the river, while in the north the Linyanti floodplains boast acacia, marula and ebony trees. The remainder of the country divides into grassland savannah and scrub more typical of Africa. The profusion of animal life and the wonder of its shades of light make Chobe a must for any Botswana safari.

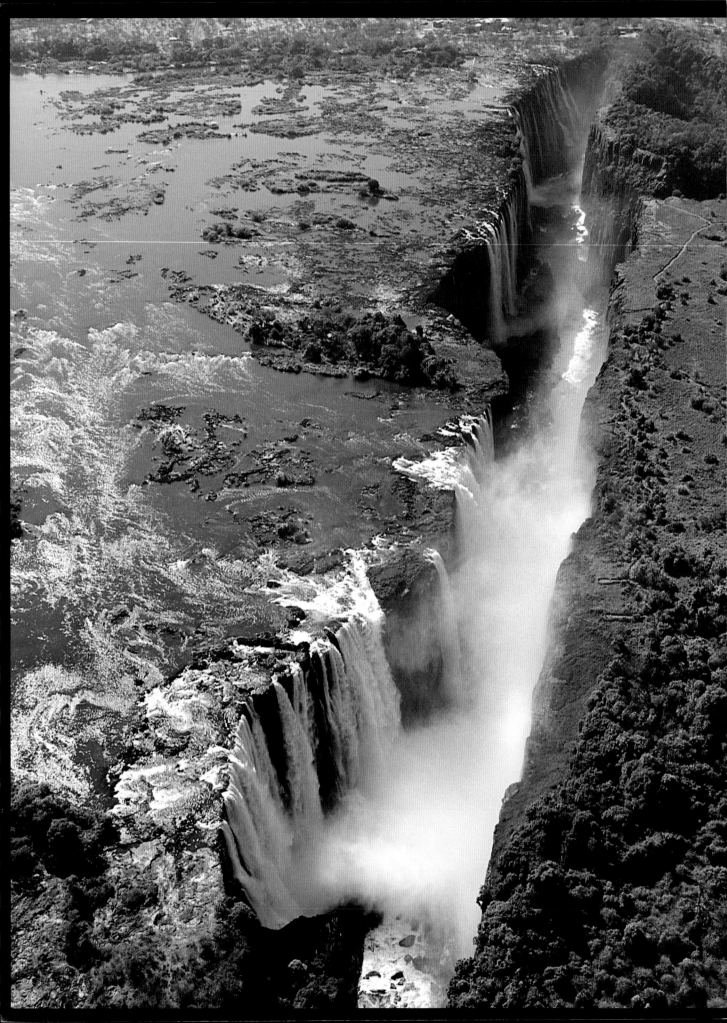

Victoria Falls
(Zambia/Zimbabwe)

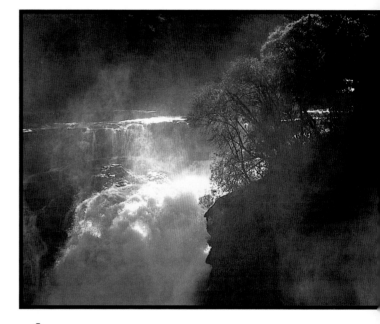

Although situated in Zambia where they provide a wonderful panorama, the Victoria Falls actually offer one of the most spectacular views from the Zimbabwe side, where they are only accessible after paying a right of entry into the park, which protects them. An established footpath conducts visitors along the falls and secondary paths lead to various viewpoints. Gigantic and infernal cataracts, they undeniably constitute one of the world's greatest heritage sites. The Falls are more than 1,700 metres long and almost 110 metres high. Here, it has to be said, everything is out of proportion. The furious roar of the tumbling waters is propagated along the gaping gorge into which they disappear. The mist of droplets lifted from the boiling waters below creates fleeting rainbows that add a touch of colour to this extraordinary sight. This is a spectacle whose immense dimensions are best appreciated by flying overhead in a helicopter. The closeness of the falls also contributes to the existence of an exuberant tropical forest inhabited by a few bushbucks that fearlessly nibble tender grass at the edge of the precipice. Some evenings on the opposite bank, a few dozen metres from where the Zambezi plunges into this giant geological fault, one can spot elephants nonchalantly crossing the river. It all adds up to a wonderful memory of Africa.

At ground level, the proximity of the Falls and their colossal dimensions obviously favours the use of a wide angle lens. However, a medium focal length zoom gives the best helicopter shots, an experience not to be missed if you can. To pick up a particular detail, such as back-lit vegetation or a close-up of foaming water, a medium focal length lens is required.

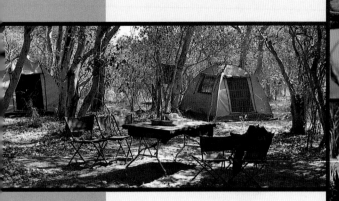

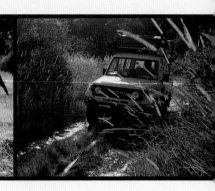

Practical tips

FORMALITIES
Valid passport (for six months after return) and a return ticket. If exiting via Zimbabwe, expect an airport tax.

LANGUAGE
English and Setswana.

CURRENCY
In Botswana: the Pula. In Zimbabwe: the Zimbabwe Dollar. In most hotels, lodges or tourist shops credit cards are accepted except Diner's Club and American Express.

WEATHER
Summer is characterised by strong downpours and runs from October to March. The weather, therefore, is hot with daytime temperatures peaking at more than 40 degrees C, notably in November and January. The dry winter takes over from May to August. The nights and mornings are cool, sometimes cold, while sunny daytime temperatures are close to 25 degrees C.

PHOTO EQUIPMENT
The usual photo equipment: cameras, lenses, tripod or monopod, flash, filters, plenty of film, cleaning kit (brush and soft cloth), rechargeable batteries, disposable batteries, a beanbag (excellent for stabilising on vehicle windows), dust protection bag, etc. Film should always be carried onto aircraft. If using digital equipment – usually big power consumers – remember to carry sufficient batteries (a cigarette-lighter adapter can also be useful) as well as several memory cards, without forgetting the indispensable external hard drive to download the cards each day while waiting to edit the photos on return.

BAGGAGE
Clothing: light items for day wear (shirts, T-shirts, trousers, Bermuda shorts); warm items for mornings and evenings in July and August (sweater, polar jacket, wind-breaker). Note that the seats in 4x4s are completely open so that early and late in the day the temperature plummets. At the risk of being teased, even a pair of gloves and a hat are often appreciated. If the trip includes Victoria Falls in Zimbabwe, a waterproof cover is essential both for the photographer and the camera. Footwear should include a good pair of walking boots and a light pair of flip-flops or trainers. Otherwise, don't forget to take: hat, sunglasses, sun cream (high factor), anti-mosquito lotion, electric torch (a head torch is very useful), personal first-aid kit, passport, air ticket, credit card and cash card.

ACCOMMODATION
For this kind of trip, the best solution in our opinion is camping. Camps allow a total immersion in the bush and a kind of osmosis with nature and wildlife. Depending on the local operator, the tent sizes vary but toilet arrangements (shower and WC) are always provided, no matter how rudimentary. Food, which is prepared on a wood fire, is usually generous and of good quality. Drink supplies are calculated as sufficient for the journey. There are some camps open to the general public that require payment of an entry fee and there are also private camps. The latter are generally off the main routes and only tour operators are authorised to use them for

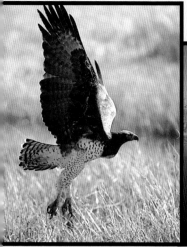

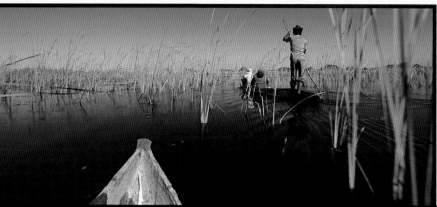

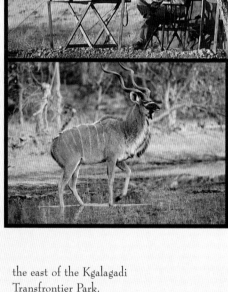

their clients. Individual travellers, therefore, have to use the public camps. The lodges, meanwhile, generally provide high quality arrangements but, apart from comfort and conviviality, they seem much less attuned to the setting.

TRAVEL

Travel is generally in a 4x4 vehicle without windows and sometimes without a roof. This is the best way to visit the reserves and affords the best visibility for taking safari shots. These vehicles travel across all kinds of terrain. In the Okavango Delta, flat-bottomed motor boats are good for exploring the labyrinthine waterways over long distances. But for a more discreet approach, the mokoro – a type of canoe shaped from a tree trunk – is a more appropriate form of transport. The operator uses a pole so the mokoro glides quietly over the water, probing the marshes via the narrowest and shallowest channels. Being narrower and less stable, however, means there is no room for hefty or bulky photo equipment in a mokoro.

PARKS AND RESERVES

Botswana allocates 19 per cent of its sovereign territory exclusively to environmental protection. The natural life – semi-virgin throughout a large part of the territory – protects one of the continent's most important concentrations of wildlife, most notably in the region between the Okavango Delta and the Chobe River. Seven main zones are officially protected and cover a total territory of 107,500 square kilometres. They are:
– Chobe National Park in the north;
– Moremi Game Reserve within the Okavango Delta in the west;
– The National Parks of Makgadikgadi and of Nxai/Pan in the centre east;
– The giant Central Kalahari Game Reserve in the lower centre;
– Khutse Game Reserve further south;
– Kgalagadi Transfrontier Park in the extreme southwest and is also accessible from South Africa which co-manages the facility with Botswana;
• Mabuasehube Reserve to

the east of the Kgalagadi Transfrontier Park.
Partly because Botswana has opted for a more elitist tourism policy, the country possesses very little infrastructure. Travellers, therefore, can enjoy a genuine experience in the bush. Coming to Botswana means immersing oneself in its environment and scenery and enjoying its extraordinary wildlife. This is because Botswana is undeniably one of the world's most beautiful and savage wildlife destinations.

Wildlife photography

Whether you are an amateur or a professional photographer, the rules of wildlife photography – particularly animal photography – are the same for everyone.

The richness of the places to visit calls for use of a large range of lenses and, depending on whether one is shooting animals or scenery, the choice of equipment and filmstock (or ISO setting on a digital camera) must be selected accordingly. Knowing your subject is, of course, very important. You need to know where different species live, their activities and patterns of life, as well as their seasonal movements. It is also important to read up on your travel destination, the physical geography, the climate and the travel itinerary. All this data unquestionably adds to the successful outcome of a safari.

Conditions for safari photography are not always ideal. The presence of dangerous animals means staying inside the vehicle at all times. Therefore, it is a good idea to find out in advance about the type of transport in order to be adequately equipped with the right photo accessories. For example, some spacious and open cars permit the use of a monopod while others only offer the possibility of working through the roof or a window. Consequently, it is important to carry a beanbag. In fact, the frequent use of hefty long focus lenses calls for great stability, which is best achieved by mounting the telephoto lens on this type of support. The bag – about three-quarters full of rice or dried beans – moulds itself around the lens barrel and provides a more comfortable camera position. For those not fortunate enough to be equipped with stabilised lenses, the bag will allow slow shutter speeds to be used when the light level is low.

Wildlife photographers attach a lot of importance to the contents of their camera bag. It should include a good selection of lenses to cover all eventualities. A long focus lens such as 400, 500 or 600mm not only allows them to take close-ups of certain timid animals that keep their distance but also to take portrait shots whose elaborate detail might be lost using other lenses. Conversely, if they prefer to set the animal in its natural context and capture something of the atmosphere in which it exists, it is best to use a medium focal length lens. A zoom lens covering 70 or 80-200mm or a telephoto lens like the 300mm is well suited to such shots.

The scenery encountered on safari in an exotic country like Botswana is often magnificent and enhanced by truly exceptional light. To capture the immense sense of space and wilderness, to express its majesty and to show its beauty, a wide angle lens is ideal. It allows a vast array of disparate elements to be combined in a single shot. Photographing a sunrise or sunset with a 20mm or 25mm lens is unrivalled when it comes to capturing the sky's infinite depth and its incredible range of colours. Whatever the lens employed, however, it is important to reproduce the atmosphere of the location and of the scene as it is experienced at the time.

Patience is important when photographing wildlife. This is a waiting game. That means waiting for good light which adds force and magic to a composition; waiting for the right movement to inject dynamism and originality into the shot; waiting for an animal's best pose in the most beautiful setting to maximise the graphic impact of its shape and form; waiting endlessly to find the best angle – into the sky or close to ground – to better tell a story and convey an idea. Each safari is unique; a voyage of discovery often with surprising sights. Take time to discover and observe new sites and species. In this way better photo opportunities will present themselves.

Wildlife photography is a marvellous discipline, a ceaseless challenge renewed by the field conditions, where nothing is ever guaranteed, all is improvised and where, even if well prepared, luck plays a big part in the success of a picture. Also, building on past experience will help to anticipate how animals may behave.

Finally, photography is a fabulous medium of expression in which the photographer can reveal his sensitivities to offer the best of his field experience. When all is said and done, a sunrise taken with 500mm telephoto, is more than just a choice of the right lens, it is also extremely spectacular.